IMAGES
of America

MOUNT PLEASANT

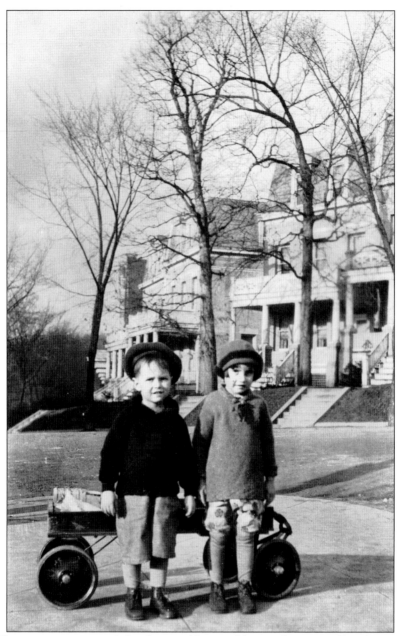

Honora Thompson, an attorney's daughter, and her neighbor, Dallas Maxwell, a pharmacist's son, paused on the corner of Walbridge Place and Park Road in February 1927. The two friends had moved with their families to Klingle Road in 1923 when the houses were new. The Park Road row houses behind them were built around 1911. (Courtesy Honora Thompson.)

ON THE COVER: Staff of the Raven Grill, 3125 Mount Pleasant Street, posed during a break on a busy day about 1954. This popular restaurant, which opened in 1935, was one of several places in the neighborhood that showcased "hillbilly" (country) bands during the 1950s. (Collection of the Logans.)

IMAGES
of America

MOUNT PLEASANT

Mara Cherkasky

ARCADIA
PUBLISHING

Published by Arcadia Publishing
Charleston SC, Chicago IL, Portsmouth NH, San Francisco CA

Printed in the United States of America

Library of Congress Catalog Card Number: 2006936426

For all general information contact Arcadia Publishing at:
Telephone 843-853-2070
Fax 843-853-0044
E-mail sales@arcadiapublishing.com
For customer service and orders:
Toll-Free 1-888-313-2665

Visit us on the Internet at www.arcadiapublishing.com

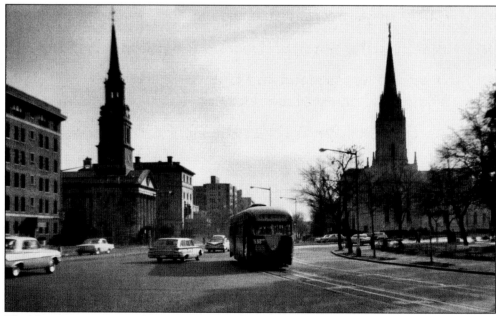

The No. 40 streetcar was photographed as it turned from Columbia Road onto Mount Pleasant Street November 26, 1961, one week before buses took over the Nos. 40 and 42 routes. Two of the three tall church steeples that mark the intersection of Sixteenth Street and Columbia Road are seen here: All Souls Unitarian (left) and the Unification (formerly Mormon) Church. (Photograph by C. Richard Kotulak.)

CONTENTS

Acknowledgments 6

Introduction 7

1. Pleasant Plains: The Most Luxurious Country Seat 9

2. Mount Pleasant Village:
 Quiet Nights and Pure Atmosphere 19

3. A Fashionable Streetcar Suburb: Along a Noble Highway 29

4. A Wonderful Place to Grow Up:
 Mid-20th-Century Mount Pleasant 69

5. An Urban Village: A Distinctive Place in the World 101

ACKNOWLEDGMENTS

I could not have completed this project without the help of many people, and I am grateful to all of them. Without Malini Dominey, there would have been no book at all, so a big thank-you to Malini for being so generous with her photography skills. Shirley Cherkasky, Brian Kraft, Rob and Linda Low, and Galey Modan also provided invaluable assistance. In addition, thanks go to the many people who generously lent me photographs, answered my numerous questions, allowed me to interview them, or provided advice. All the names will not fit in this space, but I would like to mention Tanya Edwards Beauchamp, Eddie Becker, Mary Belcher, Malvina Brown, Beverly Bussard, Olivia Cadaval, Virginia Carter, Alan Darby, Sharon Deane, Christopher and Kate Dell, Carolyn Dixon, Larry and Judy Fredette, Joan Grauman, Martha Grigg, Richard Hardy, Elinor Hart, Faye Haskins and the staff of the Washingtoniana Division of the D.C. Public Library, Fred Hays III, the Heller family, Ruth Holly, Jane Holt, Dennis Hondros, Dora Johnson, Toni Johnson, Eliza Jones, Ellen Kardy and the staff of the Mount Pleasant Branch of the D.C. Public Library, Bill Katopothis, Edwin H. Langrall, Mary Leckie, Jane Freundel Levey, Jeff Logan, Joan Majeed, Carmen Marrero, Gail McCormick, Gladys Mitchell, Gloria Mitchell, the Najarian family, Mark Opsasnick, Thomas Payette, Ruby Pelecanos, Ann Piesen, Rosanne Burch Piesen, Dorothy Pohlman, Wes Ponder, Rick Reinhard, Neil Richardson Jr., Jana Ritter, Mary Hill Rojas, the Rosario family, Bill and Julia Schartzer, Duane Shank, Donald Schwarz, the Sciandra family, Wolsey Semple, Ryan Shepard, Nancy Shia, Harold Silver, Arthur Simon, David Sitomer, Louise Smith, David Songer and the staff of the Historical Society of Washington, D.C., Nancy Suggs, Grace Tamborelle, Honora Thompson, Leo Vondas, Randy Waller, Dagmar White, George White, and Arthur Wong. Last but not least, thanks to Arcadia Publishing.

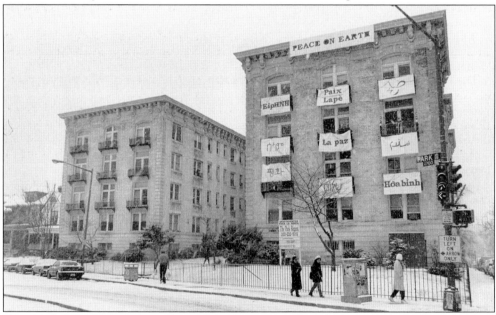

The 1993 holiday decorations on the Park Regent, 1701 Park Road, demonstrated Mount Pleasant's diversity. Although Harry Wardman built some 2,000 row houses around town, in Mount Pleasant, he contributed only apartment buildings. In addition to the Park Regent, designed by A. H. Beers and constructed in 1909, Wardman also built the Northbrook Apartments, at Sixteenth and Newton Streets, in 1917 with architect Frank Russell White. (Photograph by Rick Reinhard.)

INTRODUCTION

Residents of Mount Pleasant are proud of their neighborhood and its reputation for ethnic diversity, political activism, and elegant, cohesive architecture. From the start, Mount Pleasant residents have enjoyed a distinct sense of place.

Washington, D.C., was not a comfortable place to live in the 1850s and 1860s, and some people looked to the sylvan hills north of the smelly, malarial city as an alternative. Part of the area that eventually became today's Mount Pleasant was occupied by estates accessible only by a few dirt roads. One of these estates, subdivided just after the Civil War (1861–1865), became a settlement of former New Englanders who put down roots and went to work for the government after mustering out of the Union army.

Soon they built a village with its own post office, stores, meeting hall, civic organizations, school, and churches, as well as transportation downtown to the government agencies. The village, like the estate it replaced, was called Mount Pleasant.

By 1903, new roads and modern public transportation linked the village to downtown. The city developed around Mount Pleasant, yet it remained a distinct entity, partly because of its natural borders: the broad boulevard of Sixteenth Street on the east, Piney Branch and Rock Creek on the north and west, and wooded Harvard Street on the south. This fashionable streetcar suburb became home to many of Washington's distinguished citizens.

But by the 1930s, Mount Pleasant increasingly resembled less a well-to-do suburb than an urban neighborhood. As the first generation moved on, immigrants fleeing war and political upheaval in Europe moved into Mount Pleasant's large, sturdy, brick row houses. Would-be government workers also flooded into the city during the Great Depression and then World War II. In close-in neighborhoods like Mount Pleasant, people rented rooms or subdivided their homes into apartments. Some of the larger houses became institutions.

With desegregation came African Americans starting in the 1950s, and many white families left for the suburbs. The all-white Mount Pleasant Citizens Association lost power to the interracial Mount Pleasant Neighbors Association.

The 1960s and 1970s played out in Mount Pleasant with the arrival of idealistic young people who formed group houses and various types of collectives.

Dominicans, Puerto Ricans, and Cubans started arriving in the neighborhood in the late 1950s and Central and South Americans in the 1960s. Like the earlier European immigrants, they were fleeing war, persecution, and economic hardship and were looking for a welcoming place to build new communities. The largest group of Central Americans arrived during the Salvadoran civil war (1979–1991).

Today many of the newcomers are well-to-do professionals who are drawn to the neighborhood's beauty and the convenience of a Metro station at Fourteenth and Irving Streets. But, at least for the time being, Mount Pleasant remains a mix of the counterculture community, Latino *barrio*, and Washington urban enclave, as well as the fashionable suburb of the early 20th century. In 1987, the neighborhood was designated a historic district under D.C. Law 22-144.

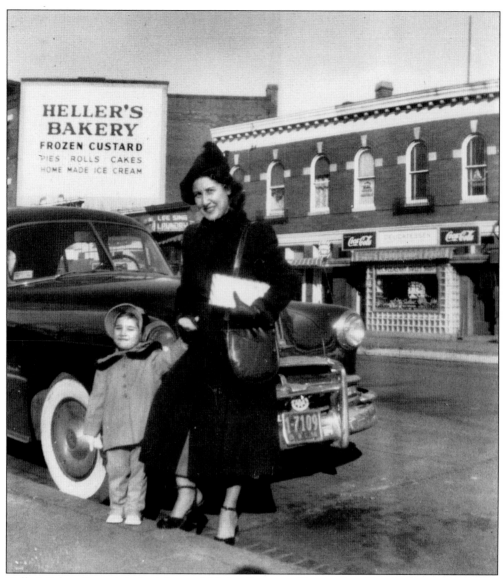

Heller's Bakery formed the backdrop as Malvina Brown and her mother, Ebrouka Brown, paused on Mount Pleasant Street on a sunny day in 1951. On Sundays, people from all over the Washington area lined up to buy bread and pastries made from the recipes the Heller brothers had brought from their family's 200-year-old business near Frankfurt, Germany. (Courtesy Malvina Brown.)

One

Pleasant Plains
The Most Luxurious Country Seat

Before 1865, the area that became Mount Pleasant was part of a large tract called Pleasant Plains that stretched from Rock Creek on the west to what is now Georgia Avenue on the east. Columbia Road was the boundary on the south. In 1727, Charles Carroll, Lord Baltimore, had granted Pleasant Plains to James Holmead, who built a house at what is now Thirteenth and Monroe Streets. Over the years, the family sold off sections of the tract, but Holmeads continued to live on Thirteenth Street into the 20th century.

South of Pleasant Plains was a 1,000-acre tract owned by Robert Peter, a Scottish immigrant and tobacco merchant who in 1879 became the first mayor of Georgetown. This tract was called Mount Pleasant, and the house that anchored it stood at what is now Thirteenth and Clifton Streets.

The main route from the city was Fourteenth Street Road, which had the same course as today's Fourteenth Street until north of Park Road it veered northwest, meeting Piney Branch just west of today's Sixteenth Street. Pierce Mill Road (now Park Road) ran approximately east-west. (Please note that Pierce also has been spelled Peirce over the years. Today the National Park Service has settled on "Peirce" for the mill.) In the early 19th century, Tayloe's Road (now Columbia Road) connected Connecticut Avenue to a racetrack at Fourteenth Street Road.

In 1854, one of the grandest of the Pleasant Plains estates, Ingleside, went up for sale. Auctioneer J. C. Maguire noted that "no expense was spared in combining all of the conveniences, comforts and elegances which can be found in the most luxurious country seat in the Union." New York congressman Hiram Walbridge purchased the 139-acre estate.

Walbridge's new neighbors counted among Washington's most illustrious citizens.

The Reverend John William French of Rosemount, west of Ingleside, had helped found the downtown Church of the Epiphany in 1842 and had risen to prominence as its first rector. Former U.S. treasurer William Selden owned the 73 acres to the east of Ingleside. Appointed marshal of the District of Columbia in 1858, Selden would have an important role in Abraham Lincoln's inauguration.

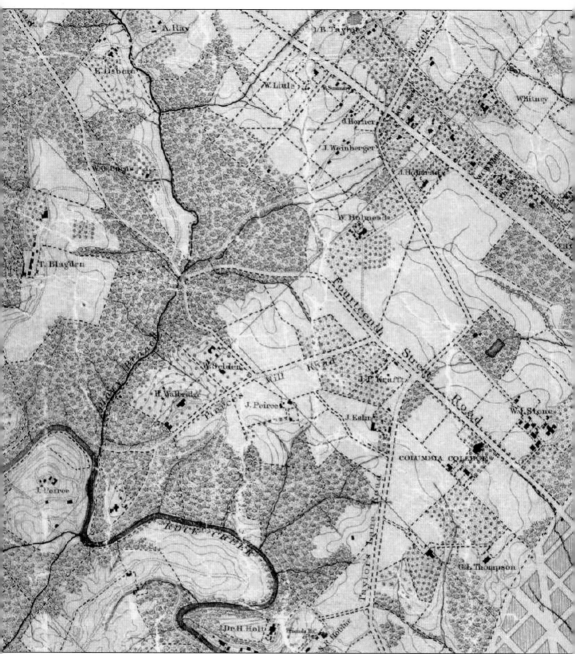

Among the estates that dotted Pleasant Plains in the late 1850s was Hiram Walbridge's Ingleside. This 139-acre property was named by Thomas Heiss, a real estate speculator who assembled the land in 1847 and then four years later sold it to the Hewlings family of Philadelphia. Other estates included the Reverend John William French's 13-acre Rosemount (west of Ingleside, in the bend of Rock Creek), former U.S. treasurer William Selden's 73 acres, and, to the north,

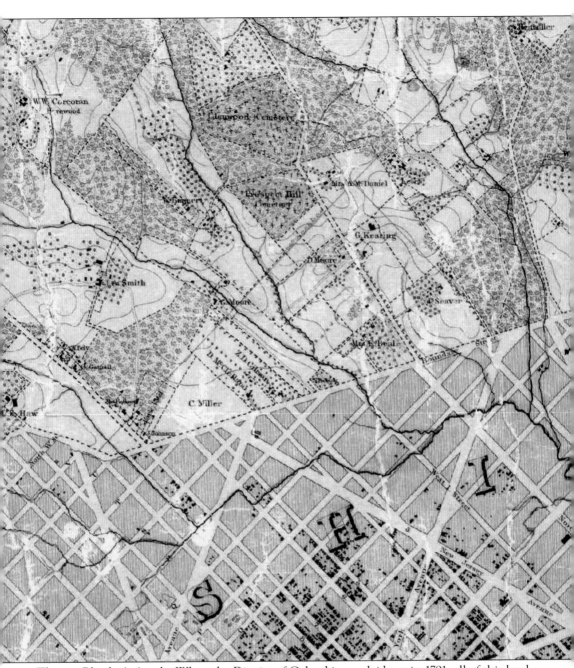

Thomas Blagden's Argyle. When the District of Columbia was laid out in 1791, all of this land belonged to James Holmead's descendants, who gradually sold it off. These pages show part of a map drawn by A. Boschke, based on his surveys completed from 1856 through 1859. (Please note that Fourteenth Street Road runs north/south until it veers left north of Pierce's Mill Road.) (Library of Congress.)

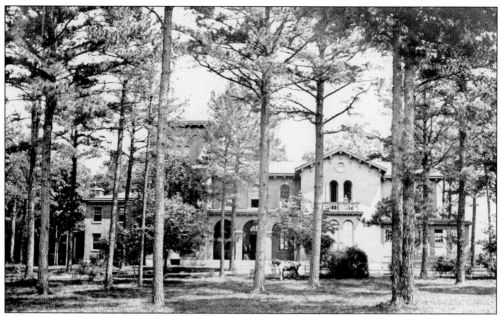

Built in 1851, Ingleside is the oldest building in Mount Pleasant still standing. It was designed by Thomas Ustick Walter, architect of the dome and wings of the U.S. Capitol, as a permanent residence for fellow Philadelphians Thomas and Mary Hewlings. However, the Hewlings never lived in the house, pictured about 1860, and in 1854 sold most of the estate at auction to Hiram Walbridge. (Athenaeum of Philadelphia.)

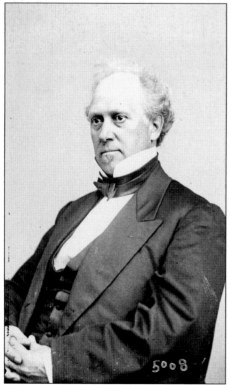

Hiram Walbridge (1821–1870) was a New York businessman and politician who served in Congress from March 1853 to March 1855. According to the *Washington Star*, guests at Walbridge's September 1, 1857, wedding at Ingleside included "nearly all the public men of note now in Washington," among them Pres. James Buchanan. There was no mention of the bride's name. (Library of Congress.)

Walbridge's stepdaughter, Helen (1842–1882), married George B. Corkhill (1838–1886), and the couple used Ingleside as their country home. As the U.S. attorney for the District of Columbia, Corkhill, seen in this photograph, helped prosecute Charles Guiteau for the 1881 assassination of Pres. James Garfield. The Corkhills' library at Ingleside was said to contain one of the largest private collections of books in Washington. (Library of Congress.)

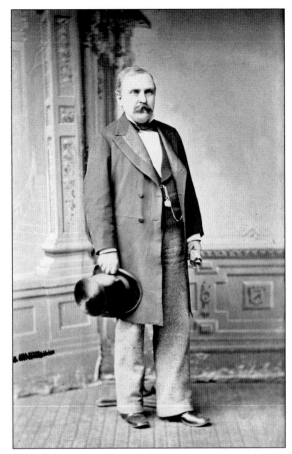

In 1889, the Walbridge family sold the portion of the Ingleside estate north of present-day Park Road to a syndicate represented by Chapin Brown (1855–1927), pictured here. Brown, the son of the original developer of Mount Pleasant, Samuel P. Brown, lived downtown but was active in the development and other affairs of the village. The syndicate subdivided the land and sold building lots. (Historical Society of Washington, D.C.)

13

Frank Noyes (1863–1948), treasurer and editor of the *Washington Star*, Washington's main newspaper at the time, bought the Ingleside mansion and 2.5 acres for his family residence in 1896. By then, the original property had been subdivided, and the house was facing an alley. When Noyes modernized the house, he moved the entrance to the Newton Street side. (Collection of Mara Cherkasky.)

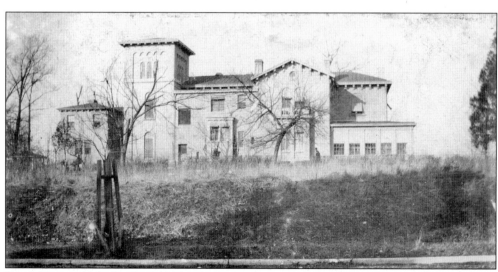

Frank Noyes sold Ingleside in 1904, a few years after moving to Chicago to head the Associated Press. Neighbor Luther S. Fristoe took this shot of Ingleside from the Park Road side, probably after Noyes's departure. The former front was now the back, and the grounds had deteriorated. (Historical Society of Washington, D.C.)

In 1842, the Reverend John William French was among the founders of the Church of the Epiphany downtown. He bought Rorymorent—which he later renamed Rosemount—in 1855. The next year, French's tenure at Epiphany ended when Secretary of War (and Epiphany congregant) Jefferson Davis appointed him chaplain at the U.S. Military Academy at West Point. Clara French sold the estate after her husband's death in 1871. (Church of the Epiphany.)

First Drag Hunt of the Season.

The Dumblane Club gave its first drag hunt of the season yesterday under very favorable circumstances. The run was started from the club house near Tenleytown and led around behind the Country Club's place through a little grove and then up the hill to the Tenleytown road, across the road and through the little valley back to Red Top in the direction of Rock creek, across Pierce's Mill road over a field and then for Dumblane. The hunt was led by Mr. Robert Neville as master of the hounds, and was participated in by Admiral Jouett, Sergeant P. Knutt, Hon. Henry Cabot Lodge, Mr. Hooe, Mr. Harvey Page, Mr. Allan Johnson, Lieut. Sullivan, Mr. George Ryder, Prof. Emmons, Mr. Montgomery Blair, Mr. Richard Dana, Mr. Robert Wallack and Mr. Franklyn Steele. A number of people followed in carriages as best they could, including Dr. and Mrs. Magruder, Miss Hudson, Dr. and Mrs. Kerr, Mr. Sidney Everett, Miss Sybil Everett, Mr. and Mrs. Arthur Addison, Mrs. Dulaney and Miss Steele.

Washington businessman Robert C. Fox bought Rosemount in 1871, and Harvey Page, a leading Washington architect, avid huntsman, and general man-about-town, acquired it in 1885. However, when Congress decided to establish Rock Creek Park in 1890, Rosemount was among the properties that were condemned and torn down. Page was mentioned in a November 28, 1890, article in the *Washington Star*, reproduced here. (Washingtoniana Division, D.C. Public Library.)

HEADQUARTERS, PUBLIC JAIL,
City of Washington, June 7, 1858.

The following Regulations are prescribed for the guidance of "The Special Police," who will act as Troopers, and assemble at the Public Jail this morning.

As the Troopers arrive at the Jail, the badges prepared for them will be placed on the lappels of their coats.

When a Trooper dismounts, a servant will take his horse, and keep him within the public enclosure until wanted by the rider.

Troopers will be detailed to ride to each precinct, and to remain there until relieved by other Troopers. Their duty will be to inform themselves of the movements and conduct of any gatherings about the polls.

On any appearance of a serious disturbance, they will, as soon as they can, learn the nature and character of it, and report the same to Headquarters.

Should any disturbance be of magnitude enough to warrant a suppression of it by an armed force, Troopers, well armed with loaded revolvers and whetted swords, will attend the Marshal to the disturbed precinct, and act against the wrong-doers, as orders and circumstances shall require.

No Trooper will possess himself of any arms at the Public Jail, without special authority, nor until the book-keeper of the Jail shall have taken down, in writing, the name of the Trooper, and a list of the arms furnished to him. After the day shall have closed, should quiet prevail in the city, each Trooper will return to the Jail whatever weapons he shall have gotten there. As this is a matter of honor, and the Marshal has become responsible to the Government for a return of the arms to the Arsenal, Troopers will remember this.

When a Trooper shall have served at a precinct two hours, he will be relieved by another Trooper. But in every such case, the relieved trooper will report himself to Headquarters for further orders.

It is hoped and expected that Troopers, whether detached or in combination, will act in concert, and respect the prescribed regulations. Without system and harmony, the service which the Troopers have undertaken to perform will become more hurtful than beneficial, and subject the undertaking to ridicule and contempt.

We have it in our power to be useful, to merit confidence, and to deserve praise. At all events, we should aim to do our duty, no matter what may happen. No good citizen desires the effusion of human blood. Yet should it become necessary for the protection of honest rights and sacred laws, each Trooper will display the spirit and vigor demanded by the crisis.

WM. SELDEN,
Marshal of the District, and Commander of the Troopers.

In 1858, former U.S. treasurer William Selden—who in 1850 had purchased 73 acres north of Park Road—was appointed marshal of the District of Columbia. His duties included issuing orders such as the one seen here, intended to prevent a repeat of the deadly violence instigated by "plug uglies"—a band of nativist Baltimore rowdies—that had occurred during the June 1, 1857, municipal election. As marshal, Selden also stood with president-elect Lincoln during his March 1861 inauguration and later kept watch at the White House as the public crowded in to meet the president and first lady. But Selden believed in the Confederacy. When the Civil War erupted, he resigned his position, sold his property to Samuel P. Brown, and moved home to Virginia. (Historical Society of Washington, D.C.)

Samuel P. Brown (1816–1898), a businessman and former Maine legislator, arrived in Washington in 1861 after Vice Pres. Hannibal Hamlin, another Maine native, appointed him naval procurement agent. During the war, Brown also ran one of Washington's first street railroad companies. Later, as a member of Alexander "Boss" Shepherd's Board of Public Works (1871–1873), Brown helped bring about enormous improvements to the city's infrastructure. (Library of Congress.)

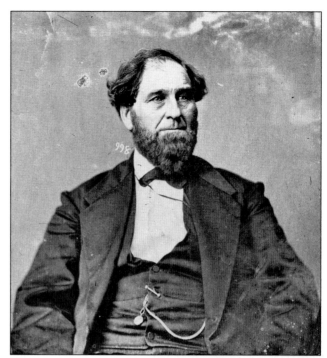

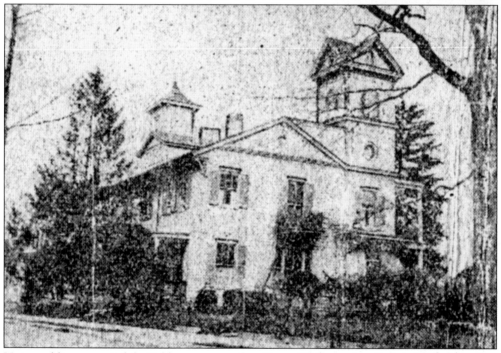

Union soldiers occupied the Selden property when Samuel P. Brown bought it in 1862. After they withdrew, he renovated the house (seen here), named it "Mount Pleasant," and moved in with his family. One of the house's two towers served as an observation platform; the other contained a water storage tank. Brown moved downtown in 1883 after a highway accident left him paralyzed. (Washingtoniana Division, D.C. Public Library.)

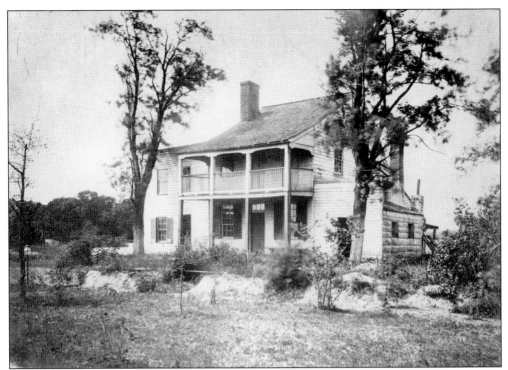

The Holmead family became the owners of a huge tract of land, including the section that later became Mount Pleasant, in 1722. Eighteen years later, they built Holmead Manor, pictured here, on what became the 3500 block of Thirteenth Street. Holmead descendants continued to own pieces of the land into the 20th century. (Historical Society of Washington, D.C.)

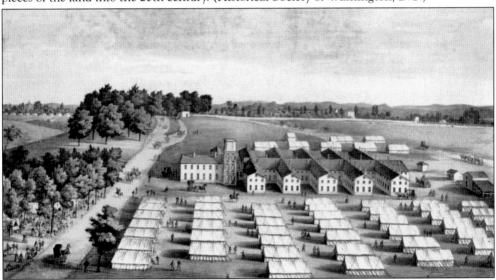

During the Civil War, this military hospital was built on a portion of the Holmead estate. It was one of several facilities along Fourteenth Street for injured Union solders. On July 2, 1863, doctors rushed from the hospital to treat Mary Todd Lincoln after she was slightly injured in a carriage accident on a nearby open lot. They sent her home to the White House to recover. (Library of Congress.)

Two

MOUNT PLEASANT VILLAGE
Quiet Nights and Pure Atmosphere

Entrepreneur Samuel P. Brown was one of the newcomers to Washington who saw a future in Pleasant Plains, the countryside north of the city. After the Civil War, Brown subdivided the eastern portion of his 73-acre estate, Mount Pleasant, and began selling lots. However, the war had hurt the city, and there was talk of moving the capital to the middle of the country, so lots sold slowly. Sales picked up as the city recovered from the war and Congress decided to keep the government in Washington. Most of the buyers were New Englanders like Brown, and many were veterans who had taken government jobs.

According to an 1879 account in the *Washington Star*, "The residences are cottages, neatly built, with comfortably arranged rooms. For each cottage is generally attached a good-sized yard. . . . Many of the villagers raise their own poultry, keep their cattle, have a garden and produce their own vegetables, and keep a neat flower garden, while some possess fine orchards. There are two good stores in the village, which supply the necessities of everyday life—meats, vegetables and fruits being brought fresh from the city everyday."

During the winter, isolation from the city did not spell boredom. Offerings included minstrel shows by the "Tropical Exotics," balls, parties and soirees, entertainments by the temperance order, a debating society known as the Mount Pleasant Lyceum, a youth debating club, and a literary organization, the Philomathic Society.

"The fact that there is no spirituous liquor sold in the village betokens a temperate, industrious, and thrifty little settlement, where there is little sickness, few deaths, quiet nights and pure atmosphere to breathe unfreighted with the nauseous gases of the asphalt nuisances, which make life bitter for city people," the *Washington Star* article concluded.

Eventually the village expanded as far east as today's Seventh Street, and the population diversified. In the 1890s, prominent African American residents of Mount Pleasant included William H. A. Wormley, son of the renowned hotelier; inventor Shelby Davidson; P. B. S. Pinchback, a former acting governor of Louisiana; and Pinchback's grandson, future writer Jean Toomer.

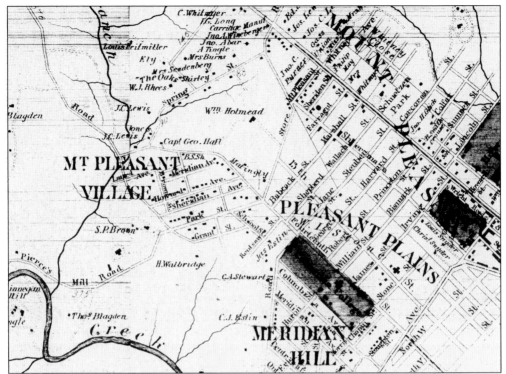

This 1879 Hopkins real estate map shows Samuel P. Brown's estate and the small settlement that developed to the east, connected to downtown by Fourteenth Street Road. (Note that Fourteenth Street Road, which crosses the middle of the map diagonally, actually runs north/south until it veers left at Meridian Avenue.) By 1885, the village comprised 137 households. (Washingtoniana Division, D.C. Public Library.)

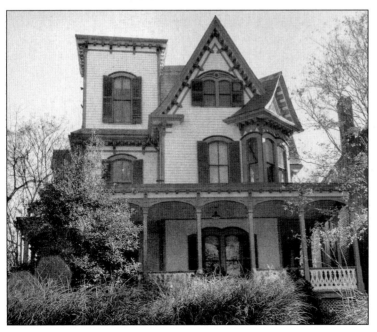

J. W. Buker's "Oakwood" was built by Samuel P. Brown in 1871 and is the oldest village-era house remaining in Mount Pleasant (at 3423 Oakwood Terrace). It originally stood on two acres. Buker, like Brown a native of Maine, served as a trustee of the Washington County schools and then as tax collector. He also served in the District of Columbia territorial government in 1873. (Photograph by Malini Dominey.)

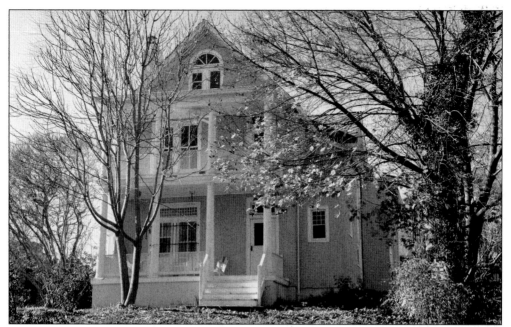

The front door of this house at 1701 Newton Street originally faced Seventeenth Street, as seen here. After S. P. Brown's son, Chapin Brown, subdivided the family estate in 1883, a government clerk named A. B. Chatfield built this house, the first one in the new subdivision, for $2,000. (Photograph by Malini Dominey.)

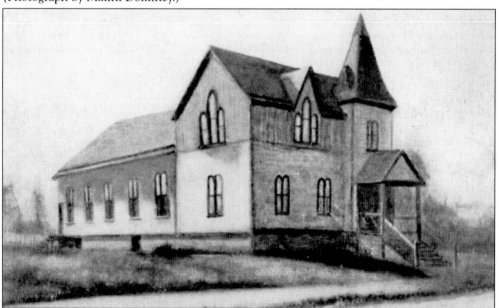

In 1870, villagers formed the Mount Pleasant Assembly, which "fearlessly discussed all questions grave or gay, political or religious, historic or scientific," according to the *Annals of Mount Pleasant*, published in 1876. A group spawned by the Assembly built Union Hall, seen here, for worship services, Sunday school, parties, lectures, and other activities, including a day-long celebration of the centennial of the Declaration of Independence. (Westmoreland Congregational United Church of Christ.)

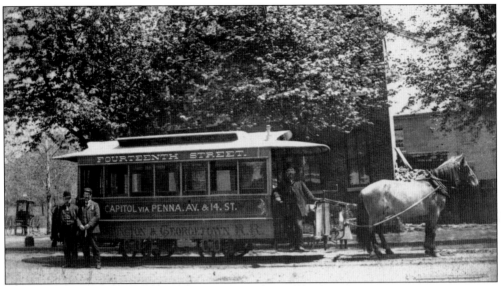

A group of villagers organized transportation downtown in the early 1870s, running a horse-drawn omnibus from Fourteenth Street and Park Road to the U.S. Treasury every morning and back every evening. In the early 1880s, the omnibus was replaced with a horse-drawn trolley, seen here. Electric streetcars came into use in 1888 and began running up Fourteenth Street to Park Road in 1892. (Washingtoniana Division, D.C. Public Library.)

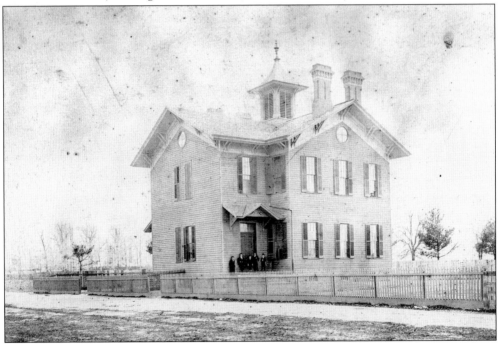

The first Mount Pleasant School, a one-room building erected in 1869 on Oak Street, had become too small by 1871, so villagers built this four-room structure on School Street (now Hiatt Place) and dedicated it in spring 1872. The Honorable Henry D. Cooke, governor of the District; the Honorable John Eaton, commissioner of education; and other distinguished individuals participated in the dedication exercises. (Charles Sumner School Museum and Archives.)

In 1895, the District built the brick Andrew Johnson School, seen here, and used the wood-frame Mount Pleasant School (right rear) as an annex before razing it in 1917. In the mid-1930s, Johnson became an annex to Powell Junior High, built in 1910 across the street. Johnson School was razed in 1965. (Charles Sumner School Museum and Archives.)

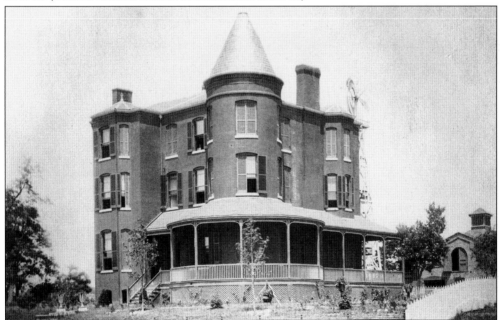

William and Mary Holmead built a new Holmead Manor at 3517 Thirteenth Street in 1890 (see page 18). During the next few years, they also built a frame duplex and another house in the same block. Between 1910 and 1913, the Leojean College for girls occupied Holmead Manor. It was converted to an apartment house in the late 1920s and continues as such today. (Historical Society of Washington, D.C.)

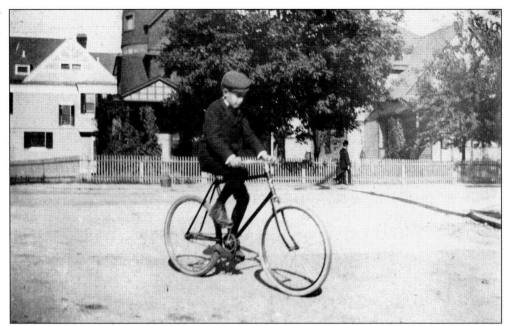

Ten-year-old Edward Fristoe rode his bike south on Mount Pleasant Street about 1898. Edward's house at 3309 Sixteenth Street extended (today's Seventeenth Street) is visible at left, and the man in the background was walking east on Park Road. The Park Ridge apartments (1673 Park Road) replaced the Fristoe house in 1925. (Historical Society of Washington, D.C.)

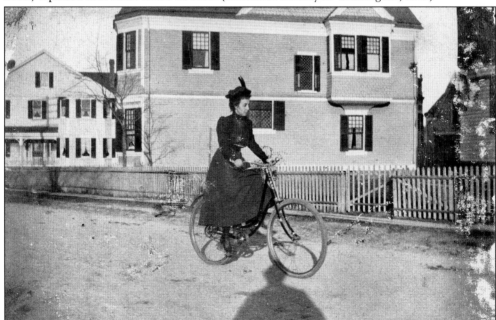

Edward's mother, Caroline Bloss Fristoe, bicycled past the family's house about 1898. When Caroline Bloss was seven years old, in 1867, her father, John B. Bloss, built his family a house at Fourteenth and Monroe Streets. Bloss had moved to Washington in 1854 and by 1876 was a practicing land agent and attorney. He also served as treasurer of the Union Hall Company. (Historical Society of Washington, D.C.)

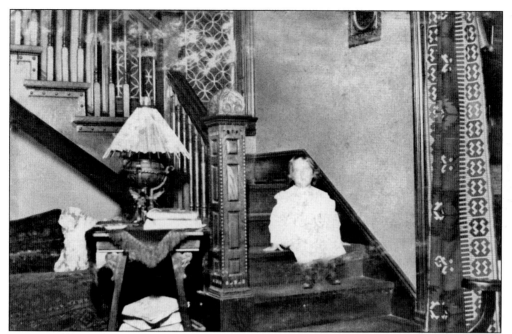

Edward's younger brother, Roy, was photographed on the stairs in their house about 1898. The children's father, Luther S. Fristoe, was a developer who built their two-story frame house in 1892. In 1909, he built the brick row houses still standing at 3102–3114 Mount Pleasant Street. (Historical Society of Washington, D.C.)

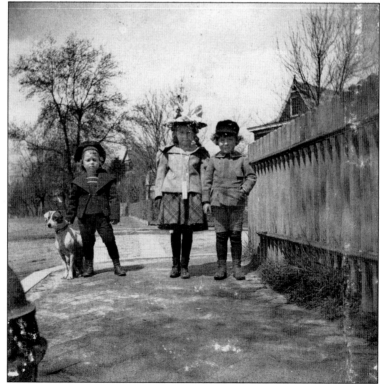

Roy Fristoe (left) and two playmates faced east on Park Road, around the corner from the Fristoe house on Seventeenth Street, about 1898. Brick sidewalks and stone curbs are visible in the photograph, as well as a fire hydrant in the left foreground. (Historical Society of Washington, D.C.)

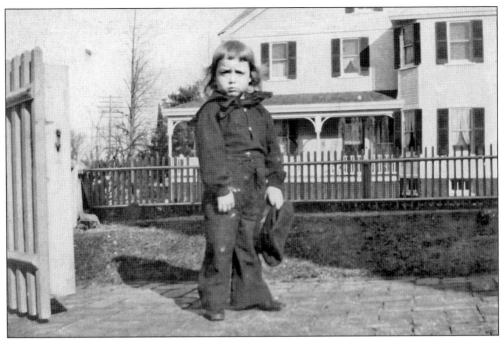

Roy Fristoe posed in the yard of his family's home at 3309 Seventeenth Street about 1898. Soon, as Mount Pleasant developed to the west, brick row houses would begin to fill in the spaces between the big frame houses. (Historical Society of Washington, D.C.)

Eight-year-old Mike Sciandra posed in front of his house at 3315 Seventeenth Street more than five decades after Roy Fristoe was photographed in nearly the same spot. In 1950, the Fristoes' house was gone, replaced by a brick apartment building, but the Fristoes' neighbors' house remained, at 3319 Seventeenth Street, and it still stands today. (Courtesy Sciandra family.)

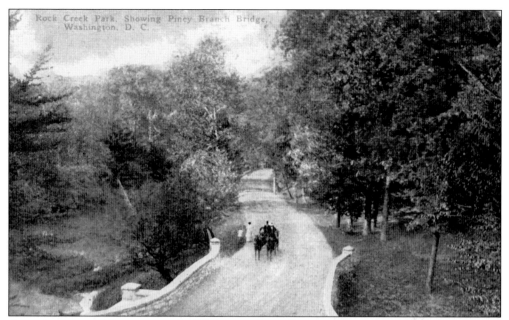

According to an 1879 account in the *Washington Star*, village resident Maj. J. T. Hall, a government clerk, quarried bluestone from Piney Branch (seen on this postcard), just north of the village. Locally quarried Potomac bluestone and Kensington tonalite remained popular building materials that still can be seen in retaining walls and porches in Mount Pleasant and throughout the D.C. area. (Collection of Harold Silver.)

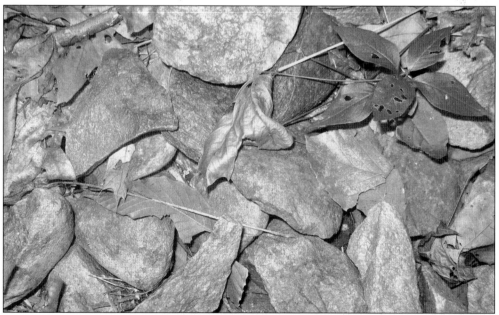

William Henry Holmes (1846–1933) was working as an archaeologist at the Bureau of American Ethnology when he discovered sites along Piney Branch where Native Americans once quarried quartzite and shaped it into tools. Shards from the 10,000-year-old work site are still visible on the steep slopes north of Mount Pleasant. Most of the shards pictured are three to four inches long. (Photograph by Mara Cherkasky.)

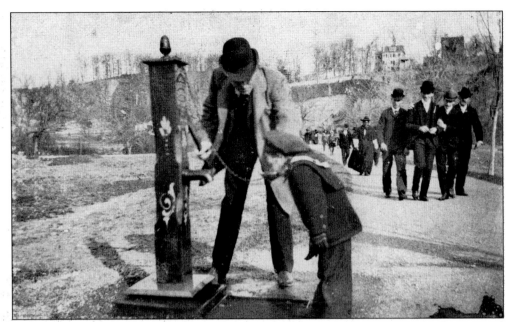

Luther Fristoe pumped water for his son Roy near the Mount Pleasant entrance to the National Zoo about 1898. Founded in 1889, the zoo has always been part of life in the neighborhood. Many residents, including Walter Johnson on Irving Street in the 1920s and Peter Schickele on Harvard Street in the 1940s, have remarked about their pleasure in hearing the lions roar. People today are more likely to hear the gibbons. (Historical Society of Washington, D.C.)

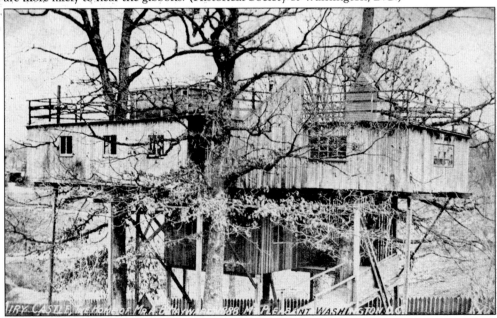

In the 1880s, a one-armed Union veteran, Capt. A. B. Haywood, built "Airy Castle" near today's Sixteenth Street and Spring Road. He also built a dance pavilion. A *Washington Star* notice of a Grand Decoration Day picnic on May 30, 1885, promised that "All who come will be welcomed to the Castle in the Trees. Refreshments . . . at city prices. Perfect Shade. Pure Air. Tickets 25 cents." (Collection of Alan Darby.)

Three

A FASHIONABLE
STREETCAR SUBURB
Along a Noble Highway

In 1903, the city finished straightening and extending Sixteenth Street beyond Boundary Street (Florida Avenue), and the Washington Railway and Electric Company extended a line from Columbia Road up Old Sixteenth Street, soon to be renamed Mount Pleasant Street. The new boulevard cut right through the village, making the old Walbridge land to the west ripe for development. Soon Mount Pleasant was looking less like a rural village and more like the city, with streets lined with brick row houses and Italianate apartment buildings.

Mount Pleasant attracted a genteel crowd. Congressmen, prominent businessmen, and government officials made their homes in the neighborhood, and it would not have been unusual to spot the president in the area. Although African American families had lived in Mount Pleasant Village, the neighborhood became exclusively white by the 1920s because of deed restrictions promoted by the citizens association.

The first businesses on Mount Pleasant Street were housed in humble, one-story brick structures: 3173 and 3215 were built in 1906, and 3201 and 3203 were built in 1909. More elaborate buildings followed, for example, Luther Fristoe's row of seven three-story brick houses at 3102–3114, to which street-level storefronts were added in the late 1920s. Many of the shopkeepers were immigrants —from China, Germany, Italy, Russia, and elsewhere.

The new Sixteenth Street, just one block away, was being praised in newspaper accounts as "a noble highway," and prominent developer Mary Foote Henderson was doing her best to make it the most fashionable area in town. She built numerous mansions to house embassies and also tried to persuade Congress to relocate the White House to Sixteenth Street. In the process, she succeeded in having the street renamed Avenue of the Presidents in 1913, but Congress reversed that a year later.

Elegant apartment buildings, inspiring churches, and a Carnegie library soon rose on Sixteenth Street.

The section of Mount Pleasant Village to the east of the new boulevard became part of Columbia Heights, but many people continued to think of the Fourteenth Street and Park Road area—the old village center—as part of Mount Pleasant. It developed as a commercial and entertainment area, one of the biggest in the city outside downtown. "Fourteenth Street was very important to us," Honora Thompson remembered.

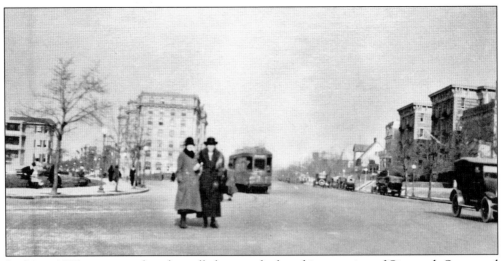

In this *c.* 1915 scene, two friends strolled across the broad intersection of Sixteenth Street and Columbia Road as a streetcar made the turn onto Mount Pleasant Street. The Kenesaw Apartment House is seen behind the women, and the Claiborne is to the right. The Embassy Apartments would not be built at 1613 Harvard Street for another 10 years, and Rabaut and Asbury parks remained bare of landscaping. (Historical Society of Washington, D.C.)

Elizabeth Walbridge, heir to many acres south of Park Road and west of Mount Pleasant Street, built two large duplexes at 1711–1713 and 1717–1719 Lamont Street in 1899. She and her family lived in 1719, to the left in this *c.* 1900 photograph. They sold off the remaining lots to developers. In the 1900 Census, Walbridge listed her occupation as "capitalist." (Washingtoniana Division, D.C. Public Library.)

Real estate company Stone and Fairfax advertised two new row houses at 3112 and 3114 Eighteenth Street on this 1910 photograph postcard. Most of today's Mount Pleasant was built between about 1900 and 1925, often in groups of row houses erected by one developer—in this case James Martin. (Collection of Harold Silver.)

As the village evolved into a more urban place, developers tore down many of the detached frame houses and replaced them with brick row houses. The team of developer Charles E. Wire and architect W. J. Wire built 1649–1663 Newton Street in 1910. (Collection of Harold Silver.)

FOR SALE BY TERRELL & LITTLE 1413-H St. N.W.

When Byron S. Adams chose to build in this neighborhood in 1903, a new streetcar line was running up Mount Pleasant Street, and Sixteenth Street had been widened and extended. Adams's printing business was thriving, and he could afford to hire one of the city's prominent architects, Frederick Pyle, to design his new house at 1801 Park Road. (Courtesy Kia Geels.)

After Adams built this Georgian Revival house in 1903, other successful businessmen followed suit, making the 1800 block of Park Road the most distinctive in the neighborhood. At right in this photograph is Charles Schafer's 1909 house at 3324 Eighteenth Street. J. H. Jolly's frame house (left) was built in the early 1890s. Adams's house became a home for the elderly in the 1930s. (Courtesy Kia Geels.)

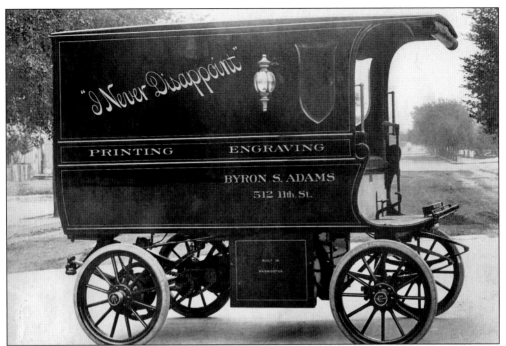

Byron Adams ordered this delivery vehicle from the Capitol Car Company ("built in Washington") about the time he moved to Park Road. His business, Byron S. Adams, Legal and Commercial Printers since 1872, continues to operate in downtown Washington. (Collection of Alan Darby.)

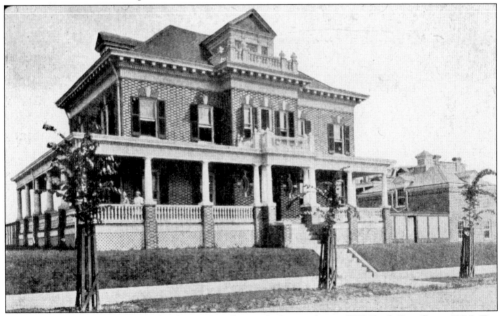

Developer Lewis Breuninger built 3225 Eighteenth Street (now 1770 Park Road) in 1906. For this project, he used Nicholas Grimm, the same architect who designed many of the row houses Breuninger built along the 1700 and 1800 blocks of Park Road. The developer and his family lived in the house, seen here in 1907, briefly before moving to upper Sixteenth Street. (Historical Society of Washington, D.C.)

Marsh and Peter designed this Gambrel-style house at 1802 Park Road in 1904. In 1940, it became the Unitarian Home for the Aged thanks to a bequest of Julius Garfinckel, the late department store founder. All Souls Unitarian Church, at Sixteenth Street and Columbia Road, closed the home in the late 1950s and sold the building. It was replaced with modern row houses in the 1970s. (All Souls Unitarian Church.)

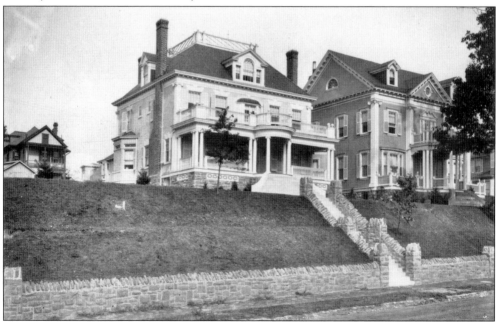

Charles Kraemer built this Georgian Revival house at 1841 Park Road (right) in 1906, using architect C. A. Didden. Kraemer, a successful wine and spirits merchant who had immigrated from Germany, died in 1932, leaving the house to his daughter Lillian Kraemer Curry. The neighboring house, number 1843, was built by physician Llewellyn Davis in 1907 to a design by A. M. Schneider. (Historical Society of Washington, D.C.)

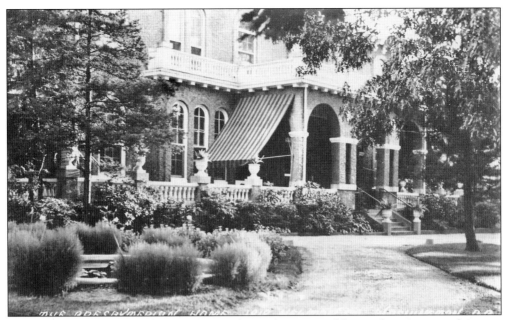

In 1917, the Presbyterian Home for the Aged, seen here, moved from a downtown row house to the Ingleside mansion at 1818 Newton Street (see page 12). The home quickly filled to capacity, so in the late 1920s, the owners added a 14-room wing, including a "commodious dining room, [and] a very complete kitchen and pantry." About 10 years later, the home expanded the building again. (Collection of Wes Ponder.)

When Sixteenth Street was extended through Mount Pleasant, 32 houses stood in its path. Some were demolished, but this one was moved in February 1903 to 1886 Newton Street from what is now the northwest corner of Sixteenth Street and Park Road. The inspector's notes show that there were complaints when the house sat for five days in the middle of Monroe Street because of bad weather. (Photograph by Malini Dominey.)

Byron S. Adams and several other neighbors purchased this Park Road triangle for $4,800 in 1906 to prevent commercial development there. In 1910, they sold the land to the city for a park (seen here in 1927). The park purchase and sale marked the revival of the Mount Pleasant Citizens Association, which had been dormant for several years. (Historical Society of Washington, D.C.)

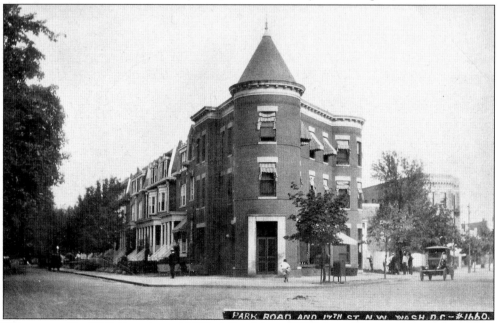

This postcard by W. R. Ross shows 1668 Park Road (now 3253 Mount Pleasant Street) about 1914. On the back is a description of the writer's second-floor apartment, which contained a dining room (bay window at right), a kitchen, pantry, hall, parlor (round bay at the front, with three windows), bathroom, and two bedrooms (left) overlooking Park Road. (Collection of Wes Ponder.)

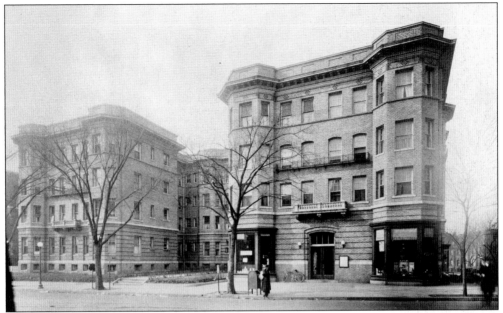

The Argyle apartment building at 3220 Seventeenth Street was designed by A. H. Sonneman and built by the Kennedy brothers in 1913. It is seen here about 1920. Intended from the beginning to house a pharmacy, the structure most likely was named for Thomas Blagden's Argyle estate north of the Walbridge tract (in today's Crestwood). One of the brothers, William Munsey Kennedy, lived at 3409 Mount Pleasant Street. (Library of Congress.)

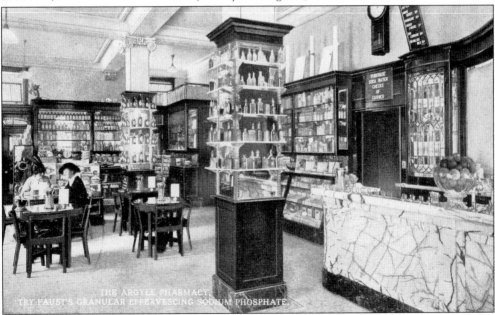

Ladies chatted over tea at the pharmacy in the Argyle about 1920. Decades later, the Argyle soda fountain became a favorite gathering place for Mount Pleasant teenagers. People who grew up in the late 1950s and early 1960s still remember the African American waitress, Hattie, who gave them free vanilla and cherry Cokes, and the pharmacists they called "Big Doc" and "Little Doc." (Collection of Wes Ponder.)

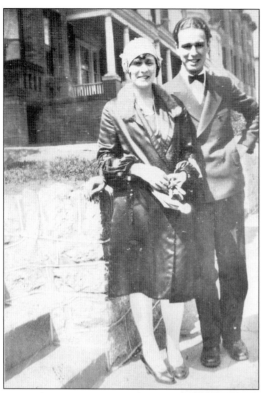

Virginia Cook and Thomas Richardson posed in front of her family home at 3102 Eighteenth Street in 1927. Virginia's father, Raymond Kingsley Cook Jr., owned a bakery at 929–931 D Street, N.W., where the J. Edgar Hoover Building now stands. Virginia and Thomas married, and years later, their grandson, Neil Richardson Jr., moved into the Ingleside Terrace house formerly owned by Raymond Cook's brother, Charles Cook. (Courtesy Neil Richardson Sr.)

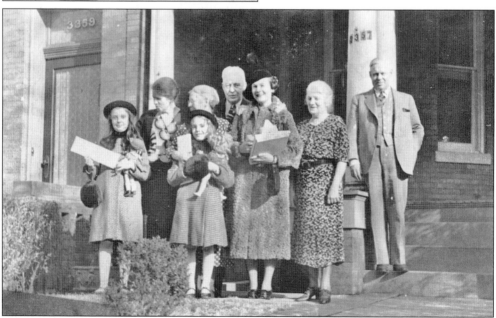

Sisters Ann (left) and Genevieve Murray visited their grandmother, Honora Murray (second row, second from left), and other relatives at 3357 Eighteenth Street on Christmas Day 1936. When the girls' father, Francis M. Murray, opened a dental practice in the Tivoli Building at Fourteenth Street and Park Road, his parents retired from the hotel business in Rossiter, Pennsylvania, and moved to this house. (Courtesy Edward Murray.)

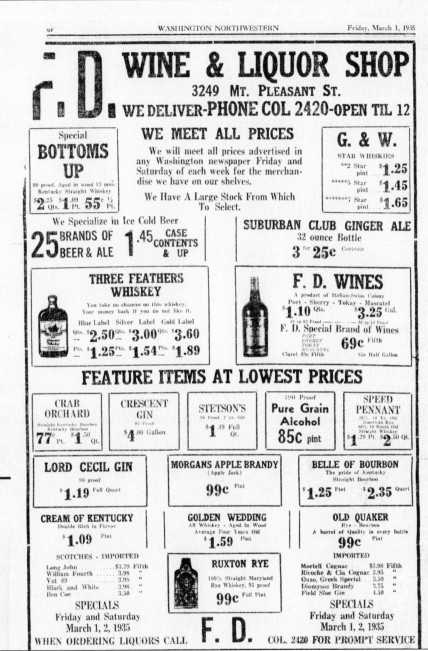

According to several former owners of this business, the original owners wanted to name it F. D. R. Liquors when they opened in 1935, in honor of the man who repealed Prohibition. When neighbors protested, the compromise became F. D. Liquors. In the early 1950s, a subsequent owner, Oscar Rozansky, foiled a holdup by backing out the front door and locking the would-be robber inside. With another change of ownership in the 1980s, F. D. became Sportsman's Liquors. Workmen renovating an old house in the neighborhood opened a wall and found a newspaper with this 1935 advertisement and gave it to then-owner Leo Vondas. Apparently the paper had been used as insulation. (Courtesy Leo Vondas.)

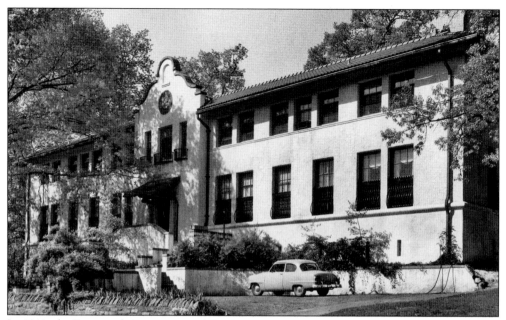

In 1911, the Episcopal Association of Works of Mercy bought property on Klingle Road and built a new facility for the House of Mercy, a reformatory/maternity home. Philanthropist Cassie James funded the Mission-style house, seen here in 1960, and Washington architect Nathan C. Wyeth designed it. Among Wyeth's other projects was a 1909 extension of the White House's west wing. (House of Mercy.)

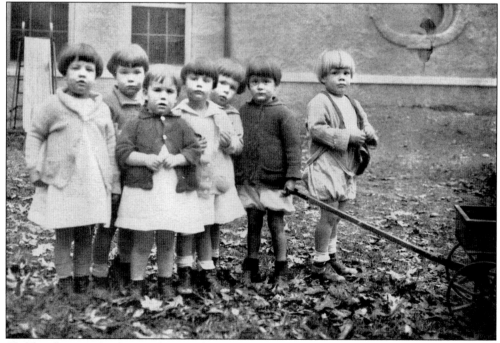

Children born at the House of Mercy during the 1920s generally lived there for about five years. About half were given up for adoption. This group of youngsters played with a wagon in the yard. (House of Mercy.)

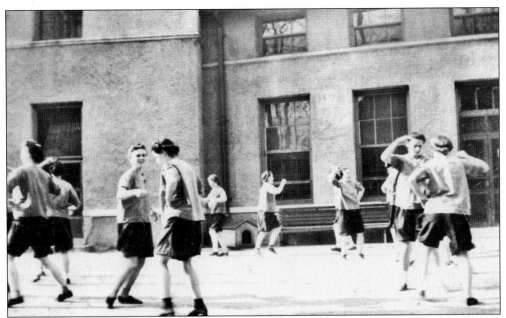

In the 1920s, residents of the House of Mercy—some of whom had entered voluntarily and others, placed there by social services agencies—wore uniforms and spent their days learning housekeeping and childcare skills. Exercise was also part of their program, as seen here. Evening activities included reading aloud and sometimes games and music. (House of Mercy.)

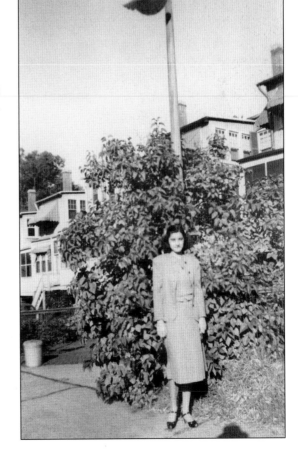

Honora Thompson, whose family moved into 2014 Klingle Road in 1923 when the house was brand-new, enjoyed hearing the girls at the House of Mercy singing vespers every afternoon at 4 o'clock. The 17-year-old was photographed in the alley behind Walbridge Place in September 1939. (Courtesy Honora Thompson.)

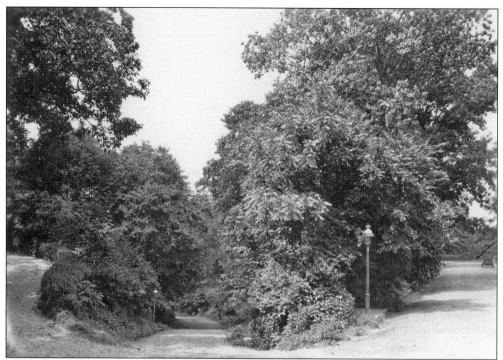

Pres. Theodore Roosevelt (1901–1909), an avid horseman, hiker, and occasional skinny-dipper, often entered Rock Creek Valley at Seventeenth and Newton Streets, so people began calling this the Roosevelt Entrance. It also became a favorite sledding place. "What a great hill, steep, lots of curves, all the way down to Rock Creek," one former resident remembers of the 1950s. Children also called it "Suicide Hill." (Historical Society of Washington, D.C.)

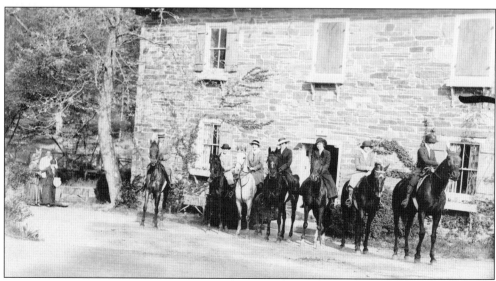

When Joshua Peirce bought a large tract of land along Rock Creek in 1794, the property included a gristmill. Peirce and his stonemason son, Abner, rebuilt the mill in 1820, using locally quarried Potomac bluestone. In this c. 1920 photograph, horseback riders paused at Peirce Mill, today the only mill remaining of what once was a string of eight along the creek. (Library of Congress.)

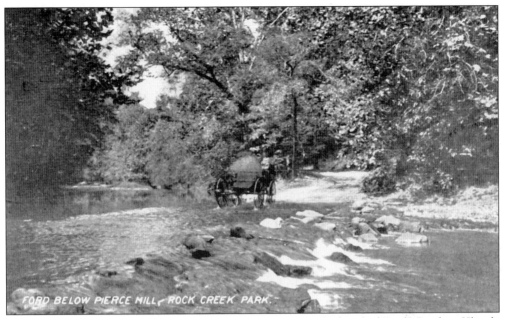

Before the National Zoo tunnel was built in the 1960s, cars had to ford Rock Creek at Klingle Road (as seen on this *c*. 1910 postcard), drive through the zoo, and then ford the creek again near the seal enclosure, former residents remember. When the zoo closed at night, drivers had to exit the parkway at Calvert Street, drive through the city, and then reenter the park above the zoo. (Collection of Harold Silver.)

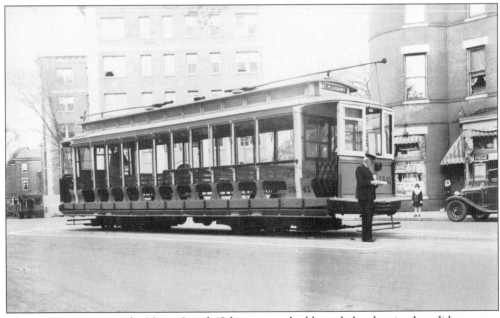

The first streetcars on the Nos. 40 and 42 lines were double-ended—that is, they did not turn around but simply reversed direction. About 1937, however, single-ended cars were introduced. To give them a place to make the turn, the city cut through Lamont Park, creating the "Loop." This photograph shows a double-ended, open-air streetcar stopped at Mount Pleasant Street and Park Road in 1934. (Courtesy C. Richard Kotulak.)

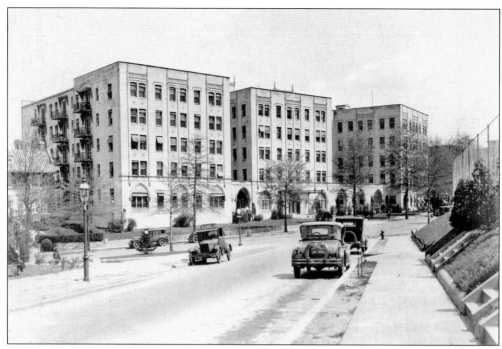

The Gothic Revival Embassy Apartments, at the corner of Harvard and Mount Pleasant Streets, were designed by B. Stanley Simmons and built in 1924–1925. The new building was photographed from Argonne Place. (Library of Congress.)

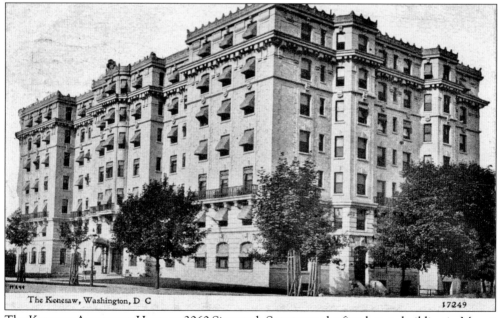

The Kenesaw, Washington, D C 17249

The Kenesaw Apartment House at 3060 Sixteenth Street was the first luxury building in Mount Pleasant. Completed in 1906, the Beaux Arts–style building designed by George W. Stone featured public parlors, dining rooms, and a café on the first floor. On the Mount Pleasant Street side were a pharmacy and two other shops. The Kenesaw is seen here on a 1913 postcard. (Collection of Harold Silver.)

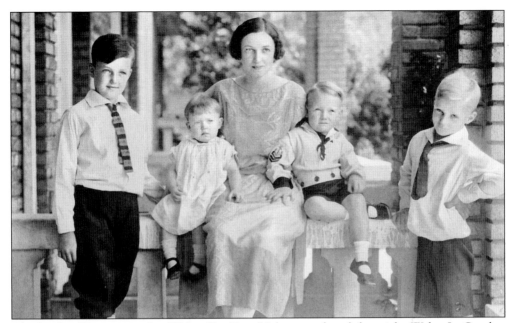

The family of Senators pitcher Walter "Big Train" Johnson—from left to right, Walter Jr., Carolyn Ann, Hazel, Robert, and Edwin—posed for a portrait on the front porch of their house at 1843 Irving Street. This was 1924, the year the Senators won the pennant. The next year, the family moved to Bethesda. In 1916, before buying the Irving Street house, the Johnsons had rented at the Kenesaw. (Courtesy Henry Thomas.)

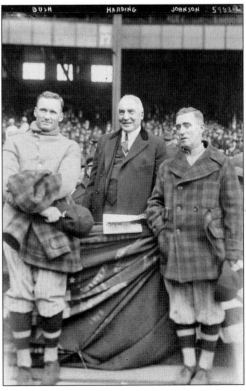

William Alexander, who grew up in the 1800 block of Kenyon Street in the 1920s, remembers that his neighbor, Walter Johnson, sometimes chauffeured the neighborhood kids to Griffith Stadium in his "open-air touring car" to watch the Senators play. Johnson also brought the children bats and balls. He was photographed in 1923 with Pres. Warren G. Harding and Leslie A. Bush (right) of the New York Yankees. (Library of Congress.)

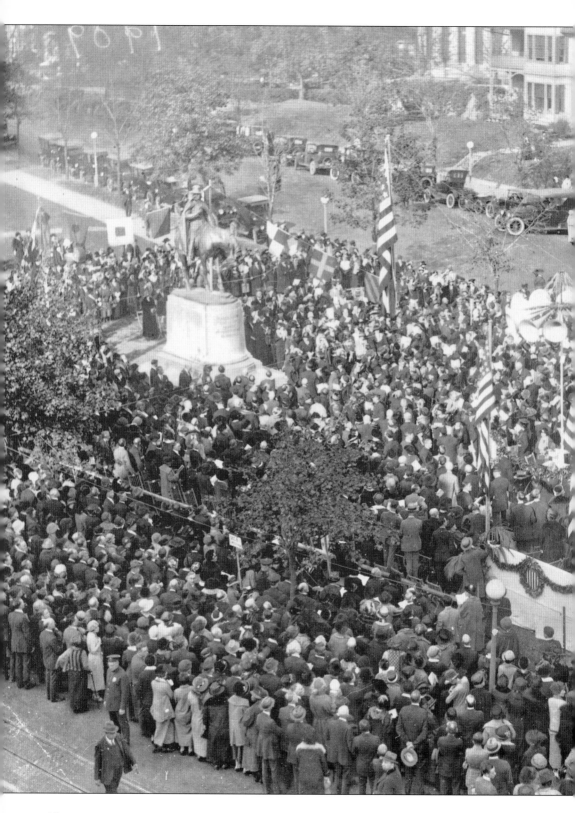

In 1913, the Kenesaw owners donated the apex of the building's triangular lot between Sixteenth and Mount Pleasant Streets to the city for use as a park. The northern and southern Methodist conventions raised the funds for a statue of Francis Asbury, first Methodist bishop in America, and commissioned Henry Augustus Lukeman to sculpt it. Pres. Calvin Coolidge dedicated the statue October 15, 1924. The grandstand is at the lower right in this photograph of the event shot from the partially completed Embassy Apartments across the street. Note the parked cars lining Sixteenth Street and the columns of Central Presbyterian Church toward the top center. Coolidge told the crowd of 5,000 that the state legislatures and U.S. Congress were not the primary places for reform. Rather, he said, reliance should be placed more upon religion. (Washingtoniana Division, D.C. Public Library.)

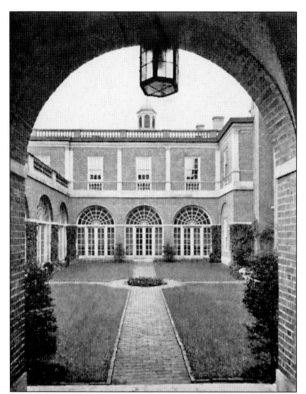

In 1924, All Souls Unitarian Church (see page 4) moved from downtown to Sixteenth and Harvard Streets, and the congregation rededicated its 1822 bell, cast by Paul Revere's son Joseph. The bell had tolled nonstop when John Brown was hanged December 2, 1859, until the mayor and council of this Southern-leaning city ordered it silenced. All Souls' Court of the Founders is seen on this postcard. (Collection of Wes Ponder.)

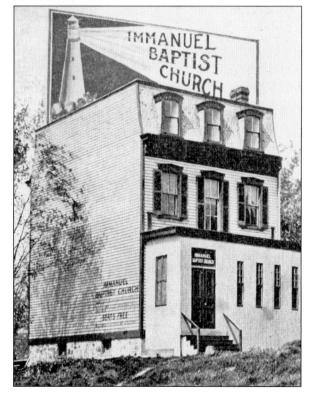

The congregation of Immanuel Baptist Church first worshipped at this house at Sixteenth Street and Columbia Road in 1906. Within a few years, the house was gone and a Bible school building stood in its place, the first step in a long-term building plan. Later the congregation changed the name to National Memorial Baptist Church. (Historical Society of Washington, D.C.)

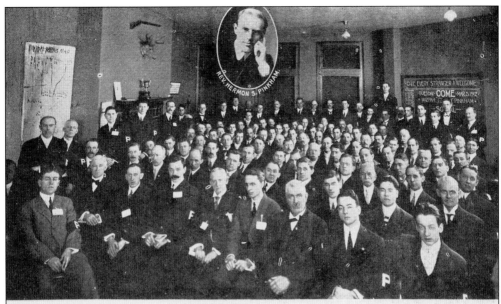

The Pinkham Bible Class for Men. Immanuel Baptist Church, 16th and Columbia Road, Washington, D. C.
Photo by Harris & Ewing.

Immanuel Baptist Church's Pinkham Bible class for men, seen on a 1912 postcard, drew a crowd. The class was named for the church's pastor, the Reverend Hermon S. Pinkham. (Collection of Wes Ponder.)

National Memorial Baptist Church at Sixteenth Street and Columbia Road, seen about 1945, was dedicated in 1926. The church's name honors Roger Williams, who was banished from the Massachusetts Bay Colony for preaching tolerance. Williams fled south, where he befriended the Narragansett Indians and in 1636 founded a colony that became Rhode Island. (Washingtoniana Division, D.C. Public Library.)

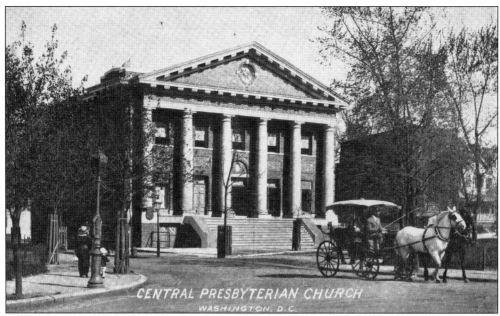

Pres. Woodrow Wilson (1913–1921) laid the cornerstone for Central Presbyterian Church December 19, 1913, and worshipped at the church, seen on this 1914 postcard, until his death in 1924. As the neighborhood changed in the 1960s, Latino groups began using the building for religious services and meetings to discuss pressing issues. In 1974, it became the Wilson Center, a Latino community center. (Collection of Harold Silver.)

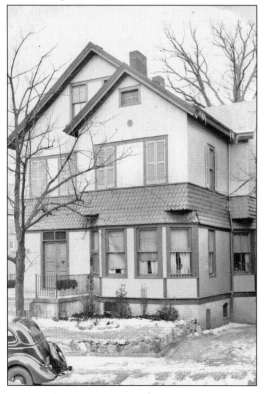

The house at 3035 Fifteenth Street, two doors down from Central Presbyterian Church, is seen here in 1936. Today it is the Latin American Youth Center's Art and Media House, offering classes and studio space. The Youth Center's offices were located at 3045 Fifteenth Street between 1974 and 1998; they are now at 1419 Columbia Road, N.W. (Collection of Wes Ponder.)

John Ernest White, the chauffeur to Presidents Wilson, Harding, Coolidge, Hoover, and Franklin D. Roosevelt, lived at 3130 Sixteenth Street from 1927 until 1945. His children, Dorothy and Jack, played on the front steps of the family's frame house, which dates to about 1890 and is still standing. (Historical Society of Washington, D.C.)

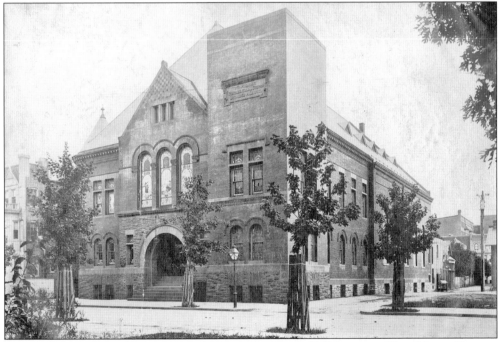

Mount Pleasant Congregational Church first met at Union Hall (see page 21) in Mount Pleasant Village in 1886. Thirteen years later, it moved to this building at 1410 Columbia Road, where amenities included a gymnasium and a bowling alley. The congregation left Mount Pleasant for Bethesda in the late 1940s and became Westmoreland Congregational Church and later Westmoreland Congregational United Church of Christ. (Washingtoniana Division, D.C. Public Library.)

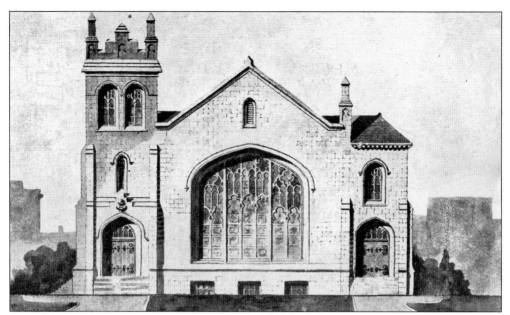

In 1909, twenty-eight people met at Post Office Hall, 1413 Park Road, to organize Mount Pleasant Methodist Episcopal Church, South. On January 1, 1916, the now much-larger congregation broke ground for a building. By Easter, the basement was complete, and services were held there. The following October, the congregation dedicated the new brick church. A drawing of the proposed building is seen on this postcard. (Collection of Wes Ponder.)

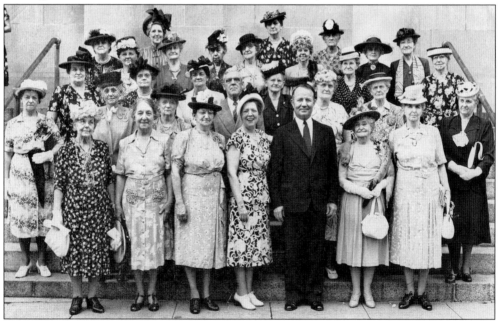

In 1927, Mount Pleasant Methodist Episcopal Church, South, was rebuilt in the more elegant style of the library and mansions along Sixteenth Street. A year later, it was renamed Francis Asbury Methodist Church. The ladies' Bible class posed in front of the church about 1950 with their pastor, the Reverend Dr. O. B. Langrall, and his wife, Isabel (at his right). (Courtesy Edwin H. Langrall.)

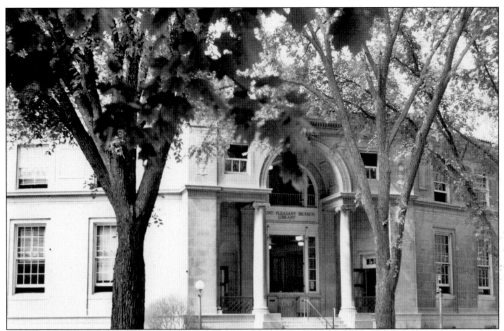

The Mount Pleasant Branch Library, which opened in 1925, was the fourth and last D.C. public library funded by the Carnegie Corporation. It was designed by Edward L. Tilton of New York, the architect for the immigration center on Ellis Island and for numerous Carnegie libraries around the country. (Washingtoniana Division, D.C. Public Library.)

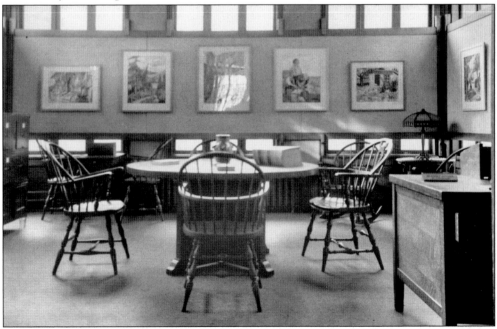

Because of its Sixteenth Street location, the Mount Pleasant Branch Library was designed to resemble a private club, with paintings hung over elegant tiled fireplaces and other luxurious features. The Washington Water Color Club often met in the sunroom, seen in this photograph from the 1920s. (Washingtoniana Division, D.C. Public Library.)

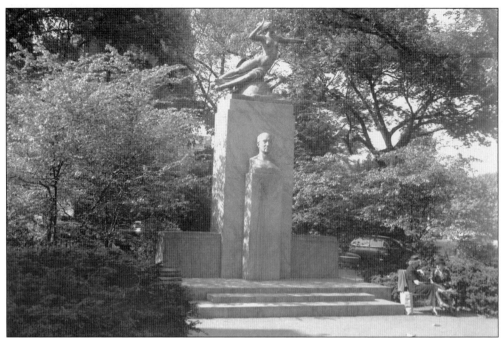

This privately funded memorial at Sixteenth and Lamont Streets honors Guglielmo Marconi (1874–1937), the Italian cowinner of the 1909 Nobel Prize for inventions relating to wireless telegraphy. The U.S. Commission of Fine Arts declined to hold a formal dedication for the memorial upon its completion in 1941 because of Italy's alignment in World War II. Also, Marconi had been friends with the Fascist dictator, Mussolini. (Historical Society of Washington, D.C.)

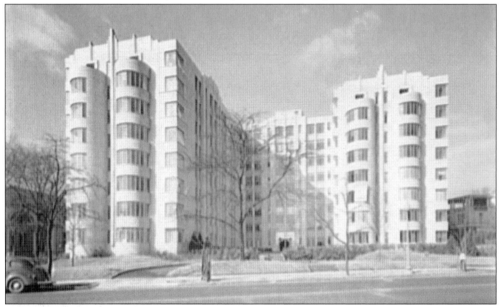

The art deco Majestic Apartment House was built by developer Morris Cafritz in 1938. In older buildings, such as the Kenesaw (built in 1906; see page 44), apartments had multiple bedrooms and servants' quarters. But as the economy shrank during the Depression, so did apartments, and the Majestic's were much smaller. (Library of Congress.)

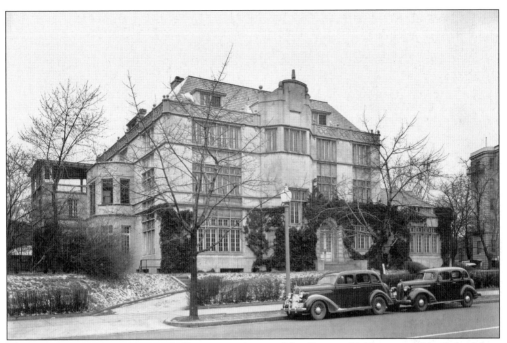

This mansion at 3224 Sixteenth Street was designed by George O. Totten and built by Mary Foote Henderson in 1922. From 1939 until 1969, the Capitol Radio Engineering Institute (CREI, pronounced CREE-EYE) operated from this building. Many of the students came from other countries, and neighborhood boys enjoyed rummaging through CREI's trash to find foreign stamps for their collections. (Library of Congress.)

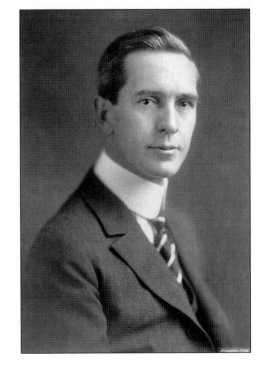

The first tenant of 3224 Sixteenth Street, from 1922 until 1930, was wealthy lawyer and politician Breckinridge Long of Missouri, seen in this 1918 portrait. As a State Department official during World War II, the nativist Long would work to prevent Jews and other victims of the Nazis from immigrating to the United States. (Library of Congress.)

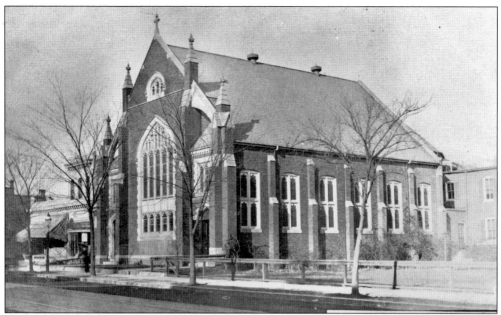

James Cardinal Gibbons authorized the founding of Sacred Heart parish in response to the growing number of Catholic families in the Mount Pleasant area. The first mass was celebrated October 15, 1899, at the old Union Hall (see page 21). Two years later, the parish had its own building, seen on this postcard, at Fourteenth Street and Park Road. By 1902, the congregation had 1,000 members. (Collection of Wes Ponder.)

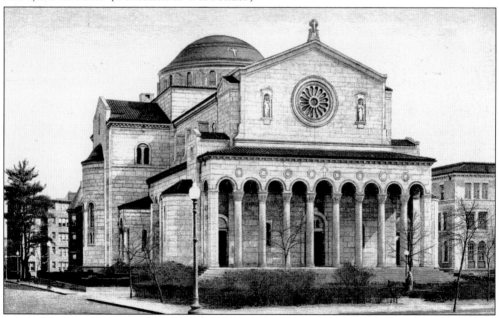

A new Shrine of the Sacred Heart, seen in this 1930s postcard, was built at Sixteenth Street and Park Road in 1922. The Tivoli Theater replaced the old church in 1924. Gifts to the new church included stained-glass windows donated by B. F. Saul, founder of the real estate empire, and the chapel, given by Estelle (Mrs. Byron) Adams of 1801 Park Road (see page 32). (Collection of Wes Ponder.)

John Joseph Earley designed and created the colorful mosaic in the dome over the apse, as seen on this postcard, and on some of the pillars in the new Shrine of the Sacred Heart. Earley, who lived at 1710 Lamont Street, also designed the decorative stonework at Meridian Hill Park and on the bird and reptile houses at the National Zoo. (Collection of Wes Ponder.)

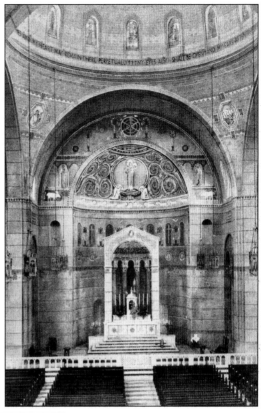

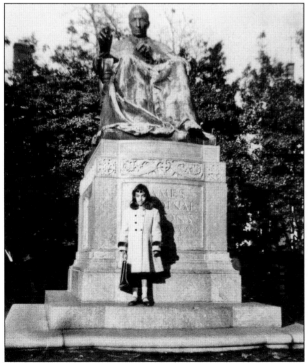

The statue of James Cardinal Gibbons across from the Shrine of the Sacred Heart at Sixteenth Street and Park Road was installed in 1932. An advisor to several presidents, Cardinal Gibbons (1834–1921) also was beloved for his support of the American labor movement. Sacred Heart student Vilma Rosario posed in front of the statue about 1954. (Courtesy Rosario family.)

In 1905, the Sinsinawa Dominican Sisters of Wisconsin purchased this 1897 house (right) and established the all-girls Sacred Heart Academy at 1621 Park Road. The house to the left was demolished to make way for the Sacred Heart School in 1930. A smaller house at the rear of the academy building dates from 1883. (Historical Society of Washington, D.C.)

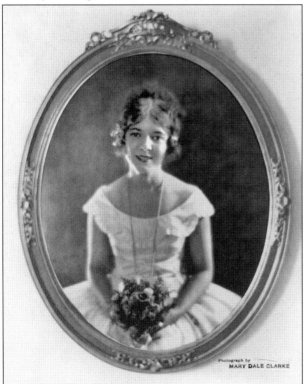

Photograph by
MARY DALE CLARKE

Helen Hayes (Brown) attended Sacred Heart Academy, among other schools, while pursuing an acting career in Washington and New York. In 1916, her father, Frank V. Brown, rented a house for the family at 3107 Eighteenth Street, but the next year, Helen left Washington permanently for New York, accompanied by her mother. She is seen here in 1921. (Library of Congress.)

The Sacred Heart eighth-grade class of 1936 posed on the steps of the Shrine of the Sacred Heart. Because Sacred Heart Academy, offering grades 9 through 12, was for girls only, graduation from eighth grade meant farewell to the male members of the class. "Sacred Heart our Alma Mater! / Proudly hail her name. / Through the years with faith undying / Loyalty proclaim," the graduates sang. (Sacred Heart School.)

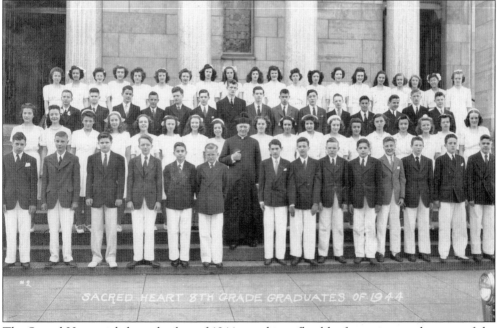

The Sacred Heart eighth-grade class of 1944 posed in a flag-like formation on the steps of the Shrine of the Sacred Heart. The school opened to African American students in 1951, and the first Latino students arrived in the 1950s. Sacred Heart Academy closed in 1974 and later became an adult education center. (Sacred Heart School.)

The Parker, built in 1908 at 1601 Park Road, was named for its owner, Olive B. Parker. The building featured a café, as seen in this 1949 image. In the mid-1960s, the Park Monroe replaced the Parker and the neighboring house, once occupied by Sen. Robert M. La Follette and his family. (Historical Society of Washington, D.C.)

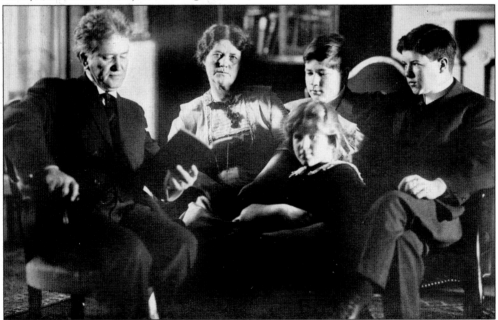

Between 1913 and 1921, Sen. Robert M. La Follette and his family lived in a large stone house at 3320 Sixteenth Street. The Wisconsin Progressive fought against U.S. entry into World War I and consequently was denounced as a traitor and hung in effigy. His wife, Belle Case La Follette, worked for universal suffrage, world peace, and other causes. The family is seen at home about 1917. (Library of Congress.)

Dorothy Isabel (Dixie) Crandall, the daughter of Tivoli Theater owner Harry Crandall, cuddled with one of her older sisters' beaux on the porch of the family house at 3321 Sixteenth Street, about 1917. Dixie grew up to marry John Payette, who worked for Harry Crandall as manager of the Warner Theater downtown. Her sister Mildred's husband, Leroy Sherman, managed the Tivoli. (Courtesy Devereux family.)

Dixie Crandall, fourth from right in the first full row, posed with her eighth-grade class June 20, 1923. Johnson was an elementary school (see page 23) across from Powell Junior High, which became Bell Vocational High School in 1948 and then Bell Multicultural High School in 1989. As of December 2006, Bell was scheduled for demolition. A replacement school opened on Sixteenth Street in early 2006. (Courtesy Payette family.)

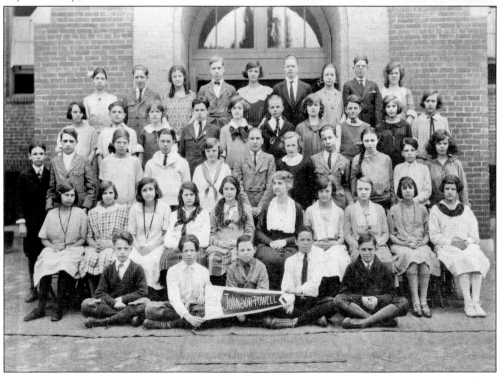

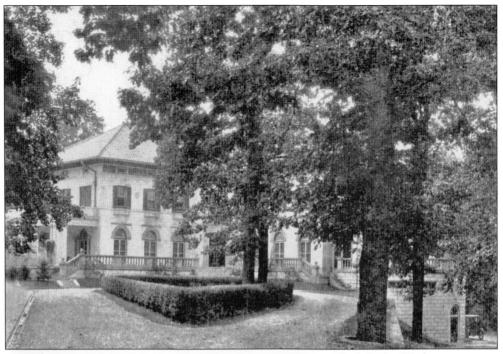

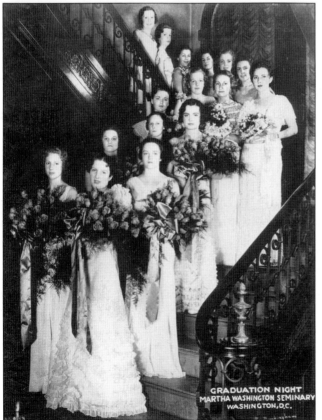

GRADUATION NIGHT
MARTHA WASHINGTON SEMINARY
WASHINGTON, D.C.

The Martha Washington Seminary, a private school for young women, operated from 1920 to 1949 at 3640 Sixteenth Street, the former John I. Cassidy estate. This postcard shows the main building, the "manor," which faced Sixteenth Street. About 1950, the school was razed and the Woodner Apartment Hotel built in its place. (Collection of Harold Silver.)

According to a 1933 account in the *Columbia Heights News*, "maidenhood from the nation over acquires charm and knowledge in the beautiful environment of the Martha Washington Seminary, nestled near the Tiger Bridge." (The Tiger Bridge carries Sixteenth Street traffic over Piney Branch Valley.) The seminary's 1935 graduating class was photographed on the stairway of the manor. (Collection of Wes Ponder.)

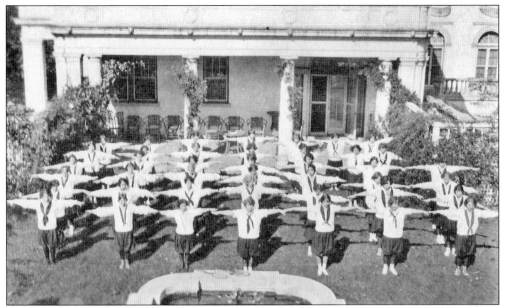

The *Columbia Heights News* in 1933 boasted of the large number of educational and religious institutions available to Mount Pleasant residents: "The present fine schools . . . are a product of the sentiment of a cultured population, of an educated and an educational community." As seen here, exercise classes were part of the Martha Washington Seminary's curriculum. (Collection of Wes Ponder.)

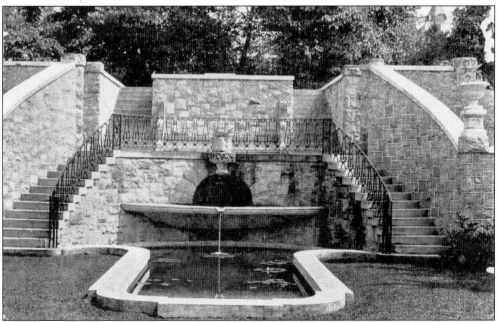

In June 1937, the Daughters of the American Revolution held a bridge party at the seminary, the *Washington Post* reported. Supper was served on the veranda overlooking the fountain court, seen here. When assistant principal (and DAR member) Sarah Stowe Whitcomb dressed up as the school's namesake, the guests remarked on her resemblance to the young Martha Washington, whose portrait hung in the school's reception room. (Collection of Harold Silver.)

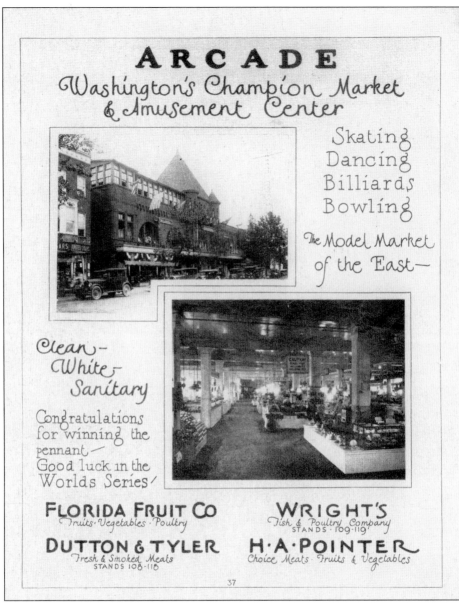

ARCADE
Washington's Champion Market & Amusement Center

Skating
Dancing
Billiards
Bowling

The Model Market of the East —

Clean –
White –
Sanitary

Congratulations for winning the pennant – Good luck in the Worlds Series!

FLORIDA FRUIT CO
Fruits · Vegetables · Poultry

WRIGHT'S
Fish & Poultry Company
STANDS · 109-119

DUTTON & TYLER
Fresh & Smoked Meats
STANDS 108-118

H·A·POINTER
Choice Meats · Fruits & Vegetables

37

This advertisement from the 1924 *Book of Washington* shows how the Arcade made Fourteenth Street and Park Road a magical place. The complex had started out as a carbarn when the electric streetcar arrived at this terminus in 1892, and then it became a market and "amusement palace" after the terminus was moved north to Decatur Street in 1907. Although Mount Pleasant residents and the board of education vociferously opposed the carbarn commercialization project, it proceeded anyway. The market on the first floor, which opened in December 1910, had 100 stalls, as well as an indoor delivery area. The upstairs Midway, which opened on Valentine's Day 1911, boasted a skating rink, dance hall, movie theater, bowling alleys, and billiard hall, as well as amusements such as the Japanese Maze, the Human Roulette Wheel, and the House of Trouble. A 4,000-seat auditorium that opened in 1926 became the home of the Washington Palace Five, the city's first professional basketball team. It also housed weekly wrestling matches. (Collection of Wes Ponder.)

This 1942 photograph, shot by Farm Security Administration photographer John Ferrell, shows Posin's butcher stall at the Arcade Market. Posin's also had a separate deli stall at the market, and both were near the Heller's Bakery stall. After World War II, Posin's moved to its own building at 5756 Georgia Avenue, and the Arcade was torn down shortly thereafter. (Library of Congress.)

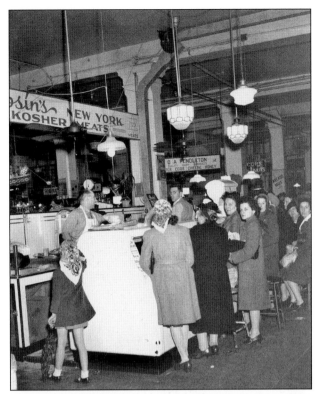

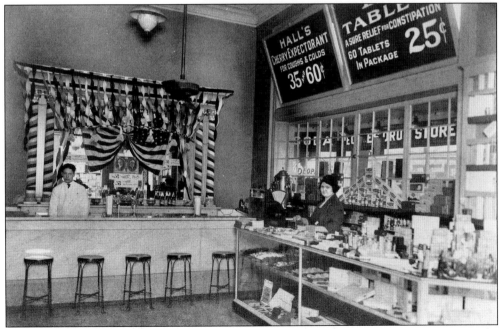

A People's Drug Store replaced Charles E. Gross Drugs at 3220 Fourteenth Street, next to the Arcade, about 1921. One of about 10 branch stores, it featured a soda fountain, as seen on this postcard. Although the soda fountain went the way of most other soda fountains in the 1960s, People's remained in this location until 1986. (Library of Congress.)

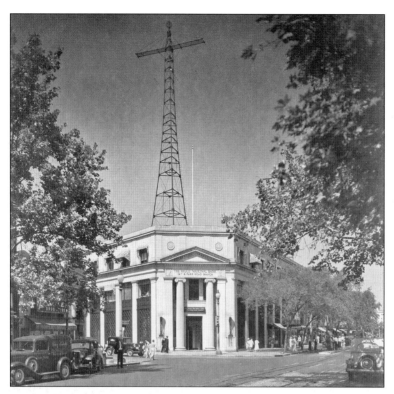

In 1923, Riggs Bank opened a branch in what it called "the very heart of Mount Pleasant today," Fourteenth Street and Park Road. The Radio Corporation of America's station WRC began broadcasting that same year from the Riggs building. It is the city's oldest radio station in continuous operation (it is now WTEM at AM 890). (Library of Congress, Theodore Horydczak Collection.)

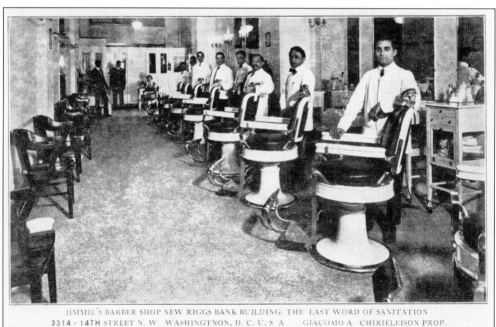

JIMMIE'S BARBER SHOP NEW RIGGS BANK BUILDING. THE LAST WORD OF SANITATION
3314 - 14TH STREET N. W. WASHINGTNON, D. C. U. S A GIACOMO A. CHIRIELEISON PROP.

Jimmie's barbershop operated out of the Riggs Bank building for a few years around 1930. Neighboring businesses included Norman Oyster's restaurant, Peter K. George's nut shop, Tremant Ladies' Wear Shoppe, Nachmann Men's Furnishings, the Stratford Gift Shop, the Garden Tea Shop, and a bowling alley in the Tompkins Building at 3330 Fourteenth Street. (Collection of Wes Ponder.)

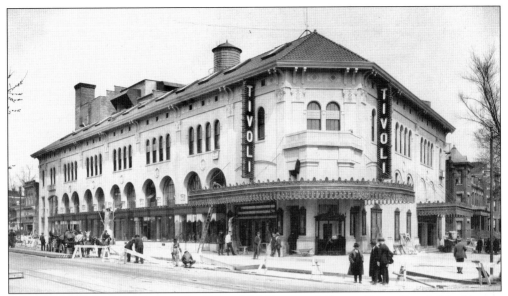

The Tivoli Theater opened April 5, 1924, at 3215 Fourteenth Street. Harry Crandall had begun planning the movie palace in 1921, but then the roof of his Knickerbocker Theater at Eighteenth Street and Columbia Road collapsed in a January 1922 blizzard, killing 98 people and injuring many more. Crandall fired his Tivoli architect—who had also designed the Knickerbocker—and replaced him with Thomas Lamb. (Robert Headley Theater Collection.)

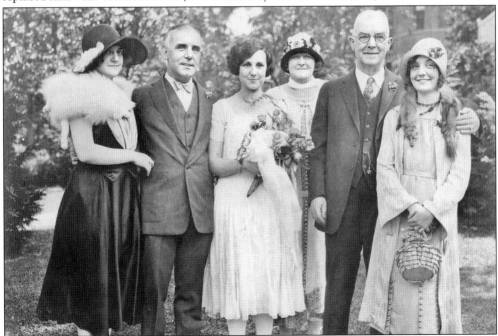

About 1917–1923, Harry M. Crandall and his family lived at nearby 3321 Sixteenth Street. Crandall made the most of the Tivoli's opening: the program included a huge parade, an opera singer, ballet, Fred Waring's Pennsylvanians, music from a Wurlitzer, and the movie *Painted Purple* with Colleen Moore. From left to right, Olga, Harry, Mildred, Catherine, an unidentified friend, and Dixie Crandall were photographed about 1928. (Courtesy Payette family.)

The Mount Pleasant School for Secretaries opened on the top floor of the Tivoli Building in 1928. Its purpose was to prepare young women and men for positions as typists, stenographers, office assistants, and private secretaries and for civil service examinations. "In selecting the quarters the choice was made with three factors in mind—accessibility of location, plenty of air and sunshine, and suitability of environment to express the personality of the school," according to the *Washington Post*. The school boasted a roof garden with space for recreation and exercise and classrooms that "have been planned to combine beauty and usefulness, so as to harmonize the severity of business discipline with the development of gracious personality." The school continued to operate from the same location into the 1940s. This 1935 advertisement appeared in the *Blue Book* (elite list) of Washington. (Collection of Wes Ponder.)

Four

A WONDERFUL PLACE TO GROW UP
Mid-20th-Century Mount Pleasant

Mount Pleasant's status as a fashionable streetcar suburb waned during the Great Depression (1929–1941) and further during World War II (1941–1945). The generation that had built the grand residences was gone, and some of these houses became homes for the elderly or other types of institutions. Many dwellings, both large and small, also were converted to apartments and rooming houses to accommodate the thousands of young people flooding into Washington to work for the expanding government.

In addition, Europeans fleeing war and other political and economic turmoil arrived in Washington, and many found their way to Mount Pleasant.

After the U.S. Supreme Court ordered schools desegregated in 1954, African American families, attracted by the reasonably priced houses, the schools, and the diverse mixture of people, began arriving in Mount Pleasant. Though some white families moved away immediately, residents continued to see Mount Pleasant as a "melting pot" or a "little United Nations." The all-white Mount Pleasant Citizens Association faded away as the inclusive Mount Pleasant Neighbors Association took on issues such as poverty and absentee landlords.

Residents of the mid-20th century remember Mount Pleasant as a wonderful place to grow up. Children had the run of the neighborhood, including the surrounding parkland and National Zoo. In an era when fewer families owned cars, alleys served as walkways and places to greet neighbors and as ball fields and play spaces.

Teenagers hung out at the Argyle soda fountain and in the Park Road triangle park. On Friday nights, they danced at Calvary Methodist Church's Teen Canteen (1459 Columbia Road) or at a clubhouse provided to them by the Reverend William Wendt of St. Stephen and the Incarnation Episcopal Church (Sixteenth and Newton Streets).

Mount Pleasant residents went out to hear "hillbilly" (country) bands at the Crosstown Lounge (3102 Mount Pleasant Street) and other nearby clubs. Then, as country music lost popularity in the early 1960s, the Crosstown became an important local venue for rock 'n' roll. Young people from all over the D.C. area also flocked to the Oasis (downstairs at 3171 Mount Pleasant Street) to dance to popular rock 'n' roll bands.

Floyd Dell, a published novelist and playwright, moved with his family to 1851 Ingleside Terrace about 1935. He took this photograph of Ingleside Terrace, and wrote this eponymous poem, in the 1940s. (Courtesy Christopher Dell.)

Ingleside Terrace is shaped like a bow.
 An arrow shot forth will fly due north.
Over the tree-tops it would go,
 And the winding drives of the park below,
And fall I know not where, but yet
 Perhaps in the Fourth Alphabet.

Ingleside Terrace, my dear companion,
 Lies on the edge, the very ledge
Of the Park's vast and fertile canyon;
 Outside our tiny urban arc,
Immense and straggling Rock Creek Park
 (Right across our narrow alley)
Dips into its deep green valley.

From our back porches can be seen
 (If we reside upon that side)
In summer only a sea of green;
 And on our slumbers, all night through,
Waves of coolness, sweet with dew,
 Pour from those green depths: we pity
Those who live elsewhere in our city.

Floyd Dell posed with his son, Chris, in the alley behind 1851 Ingleside Terrace in 1942. Dell and his wife, B. Marie, had been part of a circle of artists and writers living first in Greenwich Village and later in Croton-on-Hudson, New York. Many members of this circle moved to Washington during the Roosevelt administration, and Dell loved his job as a speechwriter for New Deal officials. (Courtesy Christopher Dell.)

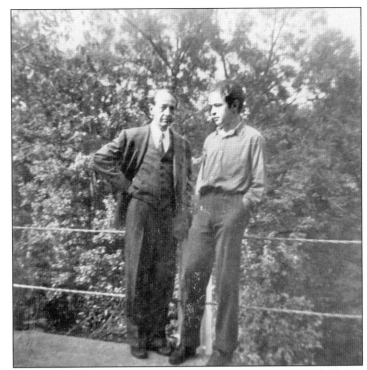

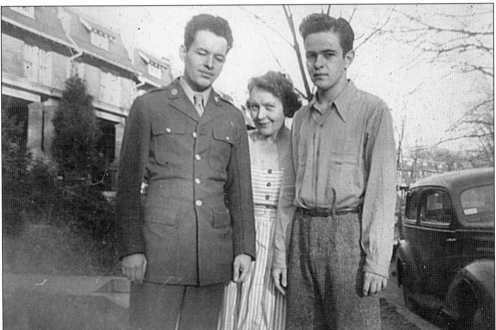

B. Marie Dell, seen here with sons Tony (left) and Chris, ran the children's room at the Mount Pleasant Branch Library. Chris Dell played the saxophone and as a teenager enjoyed hanging out at Washington jazz clubs where he sometimes was allowed to sit in with the band. The family considered Mount Pleasant to be a conservative neighborhood in a conservative town. (Courtesy Christopher Dell.)

The bedroom Peter Schickele shared with his brother David (at the door) at the entry level of 1749 Harvard Street in the mid-1940s doubled as the "Nitso" Theatre. (Nitso was a local variant of "nifty.") Admission was 1¢, and most of the plays were takeoffs on the Westerns and Tarzan movies they attended Friday nights with their father (in window). Adult plays (no fistfights) were 2¢. (Courtesy Peter Schickele.)

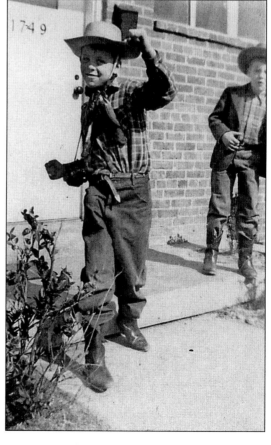

Peter Schickele (left) first heard Spike Jones's "Serenade for a Jerk" in a record store on Mount Pleasant Street and subsequently spent most of his allowance on records by the musician/comedian. "Since it was a combination of theatricality and Spike Jones that set me on the road towards P. D. Q. Bach, one might say that it all started on Harvard Street," Schickele says. His brother was the other cowboy. (Courtesy Peter Schickele.)

Helen Najarian, at left in this 1941 photograph, often took her daughters (last three on the right) and their friends on the streetcar to West Potomac Park to pick *perper* (purslane) for salads. "The gardeners were happy to see us picking weeds by the bagful," daughter Clara Andonian remembers. Armenian and Greek women also harvested a grapevine in the alley behind Irving Street for stuffed grape leaves. (Courtesy Clara Andonian.)

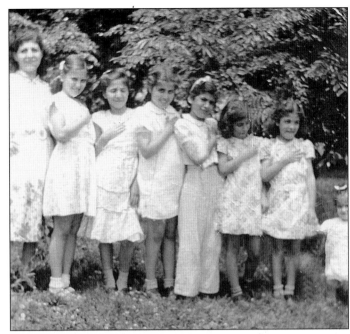

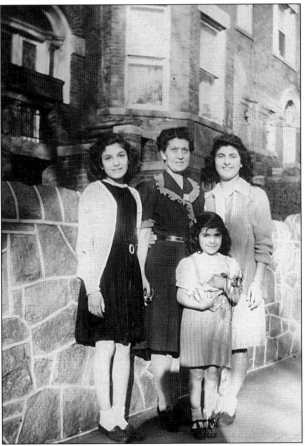

During World War II, the Najarian family of 9 also housed 15 young female government workers at 1706 Kilbourne Place. "We only had one telephone, so every time it rang, everyone would hang over the banister to see if it was for them," Clara Andonian remembers. Sisters Sosie (left) and Roxy (front) Najarian posed with their aunt Margaret and cousin Alice Baroyrian in front of the house about 1947. (Courtesy Roxy Najarian Pompilio.)

Baby Rosanne Burch was photographed with her aunt Honey Mullen in the backyard of their home at 3438 Mount Pleasant Street about 1940. At age 10, Rosanne was allowed to venture unaccompanied downtown and to the museums, to the movie theaters on Fourteenth Street, and to the library. Her house was demolished in the mid-1960s when Bancroft Elementary School was expanded. (Courtesy Rosanne Burch Piesen.)

World War II brought changes to the House of Mercy on Rosemount Avenue (see page 40). The maternity home abandoned its reformatory-like conditions, as most of the residents now were educated and employed. The average stay dropped to a few months for mothers and 6 to 48 days for babies. A member of the Ladies' Board, Marie Abbott, paid a visit to the home in 1944. (House of Mercy.)

Tom Logsdon, seen here about 1959 with his mother, Louise, and older brother Pat in front of their house at 2014 Pierce Mill Road, loved to visit the babies at the House of Mercy around the corner. To his mother's amusement, Tom began telling people he had been born there. (Courtesy Louise Logsdon.)

Each fall, the House of Mercy Ladies' Board Annual Food and Apron Sale attracted members of Washington's social set. The board solicited contributions of cakes and other items from public figures, such as Patricia Nixon and Jacqueline Kennedy, to offer at the sale. Mamie Eisenhower opened the bazaar one year, and Helen Hayes opened it another year. (House of Mercy.)

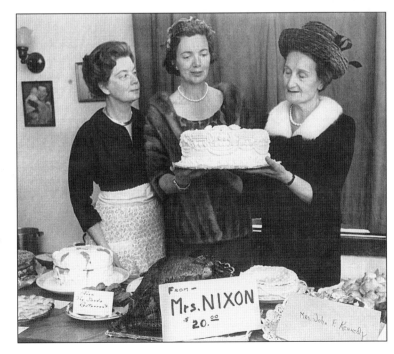

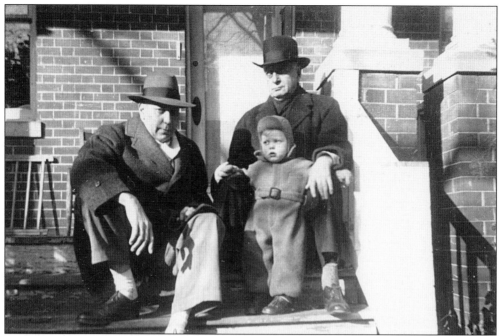

Fred Hays Sr., an art dealer and real estate speculator, built 1833, 1835, and 1837 Newton Street in 1910. He and his family moved into 1835, and his family has occupied it ever since. For this 1947 photograph, Hays sat with his son Fred Hays Jr. and grandson Fred Hays III on their front porch. (Courtesy Fred Hays III.)

When Neil Richardson Jr. bought 1873 Ingleside Terrace in 1998, he did not know that his great-uncle, Charles Vernon Cook, had owned the house decades earlier (see page 38). Raised in Washington, Cook served with the army in the Philippines during World War II, then married Charlotte Cummins and moved to Mount Pleasant. The family posed in front of the house in the late 1940s. (Courtesy Neil Richardson Sr.)

After their September 1947 wedding, Arten (Archie) and Ebrouka (Ebby) Brown lived with Archie's mother, Malvina Brown, who rented out rooms in her house at 1835 Park Road. A World War I–era Armenian immigrant, Malvina had changed her last name from Kadijian to Brown to avoid discrimination. The newlyweds were photographed returning to 1835 Park Road. They named their daughter for her grandmother. (Courtesy Malvina Brown.)

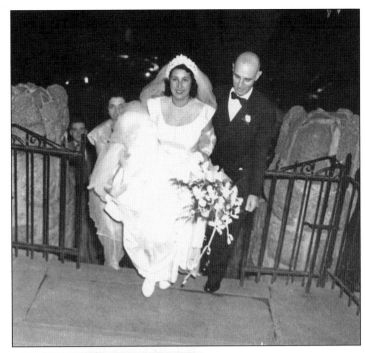

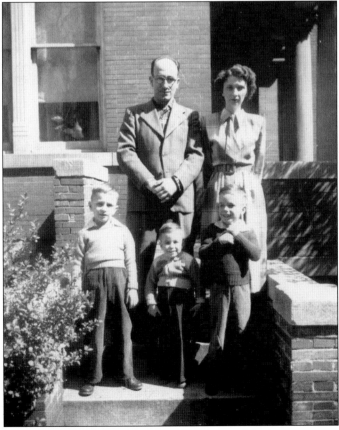

Michael and Dorothy Sciandra posed with their sons, from left to right, Mike, Joe, and Bobby on the front steps of 3315 Seventeenth Street about 1950. The family used the first floor and one of the second-floor bedrooms for themselves, renting out the other two second-floor bedrooms and the two on the third floor. Later, after removing the coal furnace, they also remodeled the basement and rented it out. (Courtesy Sciandra family.)

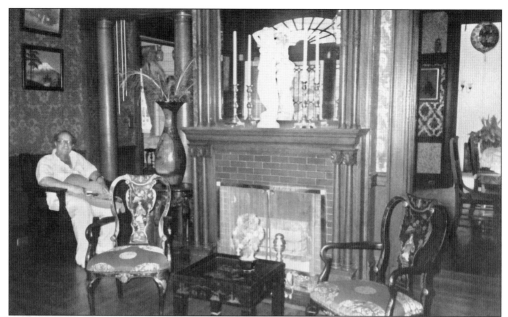

Dr. Robert Deane is seen relaxing in the reception room of his house at 1841 Park Road in 1997. Many of the furnishings remained from the original owner, Charles Kraemer (see page 34). Although in the late 1920s Kraemer had signed a covenant never to sell the house to "negroes," his daughter Lillian Kraemer Curry sold it to the African American physician in 1950. (Courtesy Marjel Deane Thomas.)

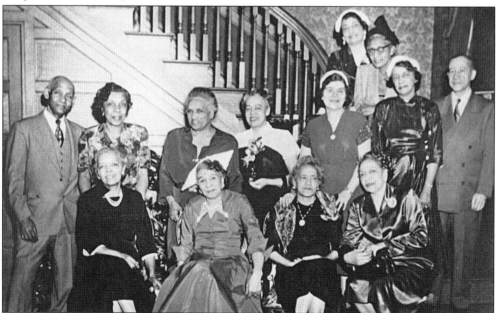

The Deanes were the first African American family to buy a Mount Pleasant house covered by a racially restrictive covenant. Some neighbors tried to prevent the family from moving in by suing them and the seller, Lillian Curry. But the U.S. Supreme Court had ruled such covenants unenforceable in 1948, so the suit was thrown out. Deane family elders posed in the reception room about 1950. (Courtesy Sharon Deane.)

Grace Tamborelle grew up at 3351 Mount Pleasant Street, the house that replaced Samuel P. Brown's original Mount Pleasant (see page 17). She was photographed on the front wall in 1956. Built by Walter Leaman in 1922 to a design by John Albert Hunter, the brick Colonial house was demolished in 1965 to make way for garden apartments. (Courtesy Grace Tamborelle.)

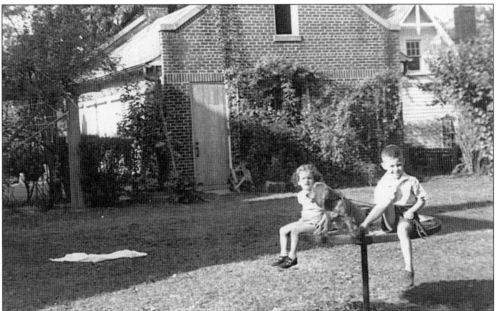

Grace and Jack Tamborelle, with their first dog, Goldie, were photographed in the backyard of 3351 Mount Pleasant Street about 1952. Realtor Lisle S. Lipscomb's frame carriage house at the rear of 3350 Seventeenth Street, through the block, is visible at right. The Lipscomb house dates from 1883, the carriage house from 1891. Both were being converted to condominiums in 2006. (Courtesy Grace Tamborelle.)

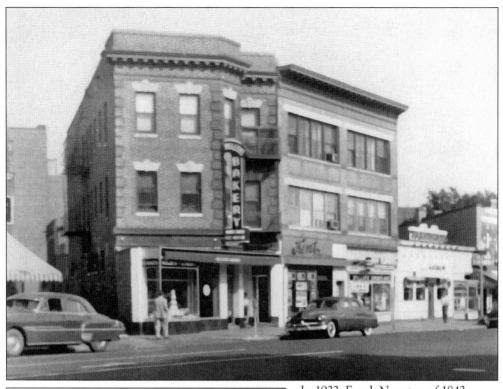

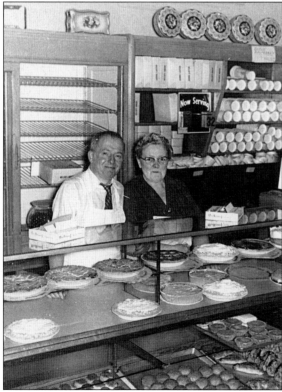

In 1922, Frank Novotny of 1842 Park Road opened a bakery at 3215 Mount Pleasant Street (the one-story building at right). The next owner, Paul Riedel of 3209 Adams Mill Road, was shot and killed in the bakery one night in early 1932. The assailant was never caught. When Riedel's widow sold the business at auction, the Heller brothers bought it and in 1940 moved it to 3221, seen here in the early 1950s. (Courtesy Heller family.)

Louis Heller posed with the business's longtime bookkeeper, Anna Smithkamp, about 1952. In 1925, at the age of 19, Louis had immigrated from Germany with his brothers August (21 years old) and William (28) to work in a relative's bakery at Northern Market, Seventh and O Streets, N.W. They also roomed with the baker, August Newland, and his family at 1325 Eleventh Street, N.W. (Courtesy Heller family.)

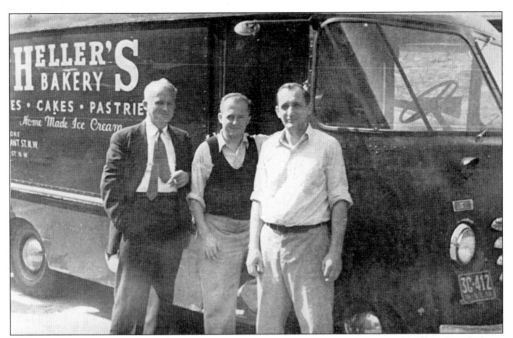

Brothers William (left), Louis (center), and August Heller were photographed beside their bakery van about 1952. Neighborhood boys liked to pilfer pastries from the van while the driver was inside the bakery retrieving another tray. Kids sometimes also slipped inside the bakery late at night to help themselves to apple turnovers cooling on racks. (Courtesy Heller family.)

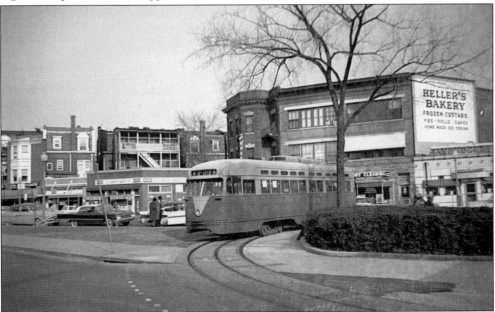

In this 1961 scene, the Mount Pleasant streetcar turned around the Loop to head back downtown. Heller's can be seen in the background, along with the Little Giant diner, which moved into Heller's old location, 3215 Mount Pleasant Street, in the early 1940s. That building, the oldest on the block, was designed by African American architect J. A. Lankford and built in 1906. (Photograph by C. Richard Kotulak.)

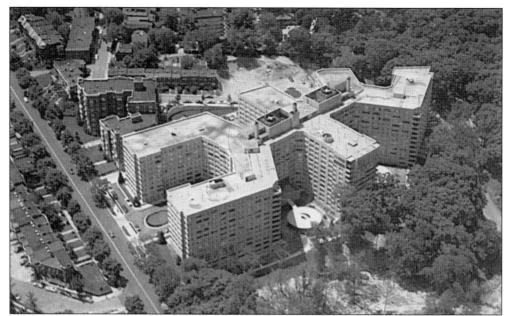

When the Woodner Apartment Hotel opened at 3636 Sixteenth Street (see page 62) in October 1951, the *Washington Post* described it as "magnificent," with "features that are destined to rank the new building among the most modern and luxurious in the world," including an "ultramodern lobby" and "sunswept roof terraces." Its 238 hotel rooms and 901 rental apartments made the Woodner the biggest apartment building in D.C. (Collection of Wes Ponder.)

The Woodner owners promised a smart restaurant and cocktail lounge overlooking the park (as seen on this postcard); three completely modern laundries with automatic washing and drying machines; broad sundecks for sunbathing and starlight dancing; floral, drug, valet, barber, gift, and coffee shops; a resident doctor; and a travel bureau. One-bedroom units started at $146 per month, and two-bedroom units started at $181. (Collection of Wes Ponder.)

Neighborhood teenagers Dolores and Ronnie Baldadian staked out the rooms of heartthrobs Annette Funicello, Paul Anka, and Gary Stites at the Woodner Hotel during the singers' booking at the Carter Barron Amphitheater the first week of September 1959. The pair succeeded in their quest. When Funicello emerged from her room, Dolores snapped a photograph with her Brownie Hawkeye. (Photograph by Dolores Baldadian.)

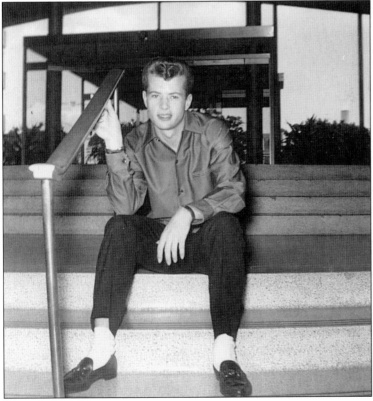

Singer Gary Stites posed in the Woodner's lobby in September 1959. He was a big name at the time, but as it turned out, the 19-year-old Stites was already at the peak of his career. His "Lonely for You" hit number 24 on the pop charts in spring 1959, and although three of his other singles landed on the charts, his popularity soon faded. (Photograph by Dolores Baldadian.)

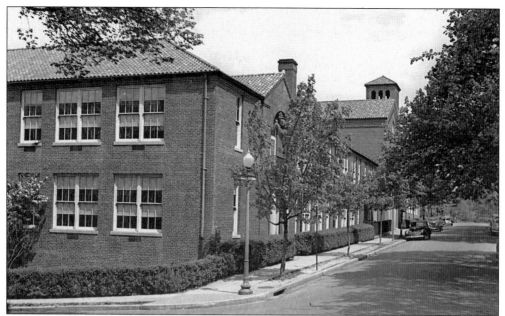

The eight-room Bancroft Elementary School, at Eighteenth and Newton Streets, could not accommodate all the neighborhood's children when it opened in 1924 and had to expand twice in the 1930s. In this 1949 view, the school extended down Newton Street. By the mid-1960s, all the houses in the 3400 block of Mount Pleasant Street had been razed to make way for another addition. (Historical Society of Washington, D.C.)

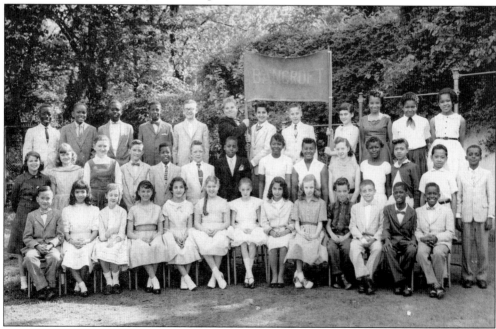

The Bancroft Elementary School sixth-grade class posed at the end of the 1958 academic year. Four years after *Brown v. Board of Education*, Mount Pleasant gradually had become more racially mixed. Gloria Mitchell remembers she began to notice "serious diversity" in the neighborhood in the 1970s, when Bancroft students spoke 27 different languages. (Courtesy Grace Tamborelle.)

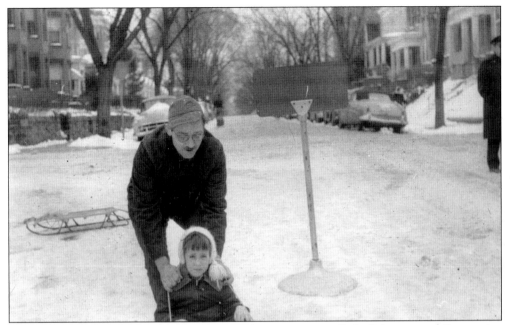

Sledding on Mount Pleasant's hilly streets is a favorite memory. Ruby Pelecanos recalls coasting down Irving Street to Kenyon Street in the 1930s, and older kids in the 1950s flocked to Seventeenth Street, where they could sled all the way to Piney Branch. Hubert Leckie gave his daughter Barbara a push down Eighteenth Street alongside Bancroft Elementary School about 1954. (Courtesy Mary Leckie.)

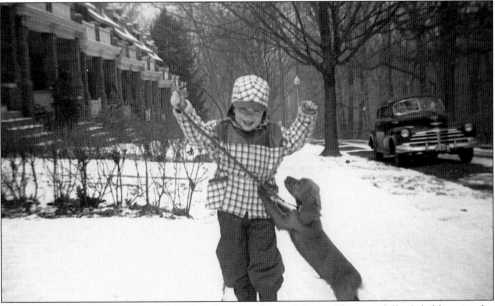

Louise Logsdon, of 2014 Pierce Mill Road, remembers a Mount Pleasant full of children in the 1950s. They trick-or-treated all over the neighborhood, played in Rock Creek Park, skated on the creek, and fed the ducks near Peirce Mill. On hot summer nights, families sometimes slept in Rock Creek Park—or at Hains Point. Here her son, Patrick, played with his dog on snowy Pierce Mill Road in 1955. (Courtesy Louise Logsdon.)

After the 1948 communist coup in Czechoslovakia, a Czech enclave anchored by the Council of Free Czechoslovakia formed in the 2000 block of Park Road. Among the residents of "Czech Row," or "Prague Road," were the Czech Army's top general, Antonin Hasal, and the former Czech ambassador to Turkey. This couple, Frantiska and Josef Fogl, lived at 2065 Park Road. (Courtesy Jana Koeppl Ritter.)

Dagmar Hasalova White (left) posed on the porch of the family house at 2053 Park Road with her mother, Josefa Hasalova (center), and sister-in-law, Grethe Petersen Hasal, in April 1960. They were on their way to her sister's wedding just one week after the death of their father, Gen. Antonin Hasal. (Courtesy Dagmar White.)

Stamata Tagalos (left) posed with her daughter, Alice Frank; great-granddaughter, Jeannie Pelecanos; and granddaughter, Ruby Pelecanos, in the living room of the family's house at 1745 Irving Street in 1947. Ruby and her husband and children moved to Silver Spring in 1953. (Courtesy Ruby Pelecanos.)

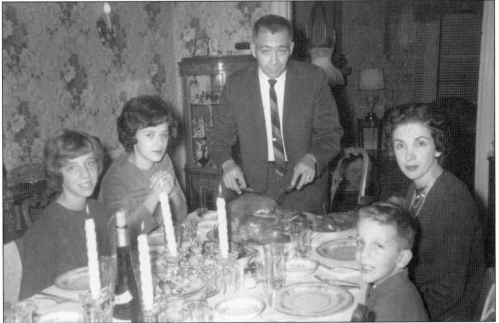

George Pelecanos (right foreground) celebrated Thanksgiving 1962 at his grandparents' Irving Street home with (from left to right) his sisters, Alice and Jeannie, and his parents, Peter and Ruby. Pelecanos has authored a series of crime novels set in and around Washington. His *Right as Rain* (2001) takes the protagonist to the Raven (see cover) and Sportsman's Liquors (see page 39) in Mount Pleasant. (Courtesy Ruby Pelecanos.)

Merv Conn opened an accordion school at 3509 Fourteenth Street in 1945. Occasionally Conn was invited to bring students to perform at Mount Pleasant Citizens Association functions at the library. But he also performed at the White House and on the presidential yacht, and he taught Vice Pres. Richard Nixon's daughters the instrument. This c. 1950 photograph shows Conn (left) performing with some of his students. (Courtesy Merv Conn.)

THE BLUE SKY BOYS

Bill Bolick Earl Bolick Curly Parker

In the mid-1950s, William Bolick left Hickory, North Carolina, to find work in Washington. With his brother Earl, Bolick had performed as the Blue Sky Boys, but music had stopped paying the bills. One day, in his rented room on Park Road, Bolick was pleasantly startled to hear a country tune from a second-story window across the street. Upon investigation, he found young Charlie Waller playing his guitar. (Courtesy William Bolick.)

Charlie Waller (upper right) grew up in his mother's rooming house at 1747 Park Road and in 1957 founded the Country Gentlemen. Banjo player Eddie Adcock (lower right) remembers that the Country Gentlemen played only once on Park Road: when the Kingston Trio was in town in 1959, the two bands got together to swap songs. Also pictured are bassist Jim Cox (lower left) and mandolin player John Duffey. (Courtesy Randy Waller.)

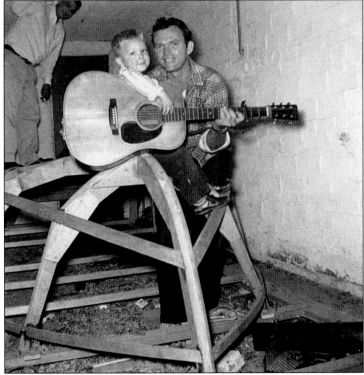

With his sweet tenor, Charlie Waller (1935–2004) became one of the most popular bluegrass musicians ever and was part of the reason Washington became known as the nation's bluegrass capital. Neighbors remember seeing Waller working on boats in the yard of 1747 Park Road. He and son Randy posed about 1962 (not in Mount Pleasant) with one of his boat projects. (Courtesy Randy Waller.)

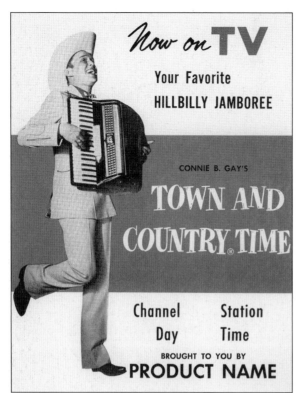

About 1954, musician Jimmy Dean rented rooms at 3303 Eighteenth Street. The next year, he began hosting the popular local TV show *Connie B. Gay's Town and Country Time*. He is seen here on a sample poster included in a promotional package for the show ("Hillbillies are Big Business!" the accompanying brochure promised). Later Dean became better known for his sausage. (Collection of George T. Merriken, courtesy Jeff Krulik.)

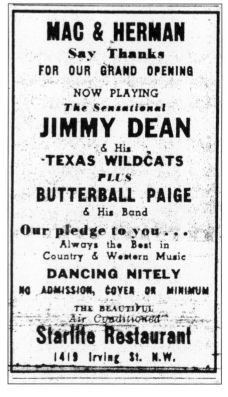

Jimmy Dean and the Texas Wildcats were the house band at the Starlite Restaurant when the place opened in July 1954 at 1419 Irving Street. Former Mount Pleasant residents also remember seeing Patsy Cline and other country greats at the Starlite. In the 1960s, many clubs, including the Starlite, switched to rock 'n' roll. This 1954 advertisement is from the *Washington Daily News*. (Washingtoniana Division, D.C. Public Library.)

Malvina Brown and her mother, Ebrouka Brown, posed in front of 3303 Eighteenth Street in 1951. Originally built in 1906 to a design by Frederick Pyle, the architect responsible for 1801 Park Road across the street (see page 32), this address remained a single-family dwelling until about 1954. It then became a rooming house, and Jimmy Dean was among the tenants. (Courtesy Malvina Brown.)

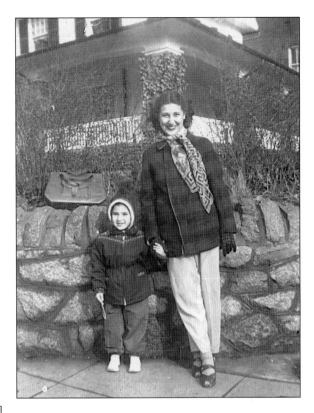

TUES. THRU SUNDAY
RAY ROCK
& THE REVLONS

SUN. JAM SESSION
3 TO MIDNIGHT
AND MONDAY NITE

SKEETER COOPER
& THE SOUND TRACKS

HALLOWEEN PARTY
SUNDAY FROM 3 P.M.

CROSS TOWN LOUNGE
3102 MT. PLEASANT, N.W.

In 1965, the Crosstown Lounge showcased rock 'n' roll, as seen in this advertisement from the *Washington Daily News*. But in the late 1940s, the club featured Zeb Turner's hillbilly band, and owner George Lowe sometimes took the mike. In later incarnations, this building housed a strip joint, an African restaurant, a jazz club, and, now, a Salvadoran restaurant, Haydee's. (Washingtoniana Division, D.C. Public Library.)

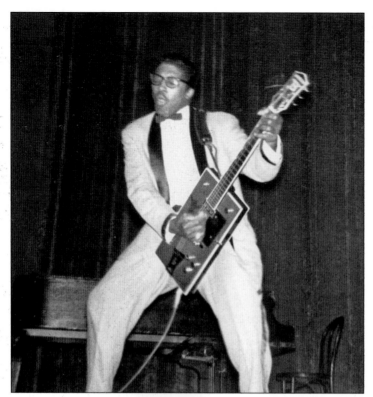

In the summer of 1962, R&B star Bo Diddley was living with his wife, Kay, and baby daughter, Terry, in a first-floor apartment at 1724 Newton Street. Neighborhood boys enjoyed hanging out at the apartment, listening to music, and watching Bo Diddley fashion his ingenious guitars. Some of the boys, including Charlie Rivera and Donnie Schwarz, formed their own band. (1961 photograph by Ron Courtney, courtesy George White.)

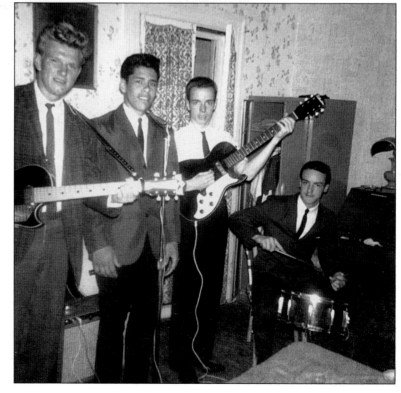

In the early 1960s, a band occasionally known as J. C. and the 3Ds played current hits at parties and other events. From left to right, Dave Radigan, Charlie Rivera, Bobby Hamilton, and Donnie Schwarz rehearsed in the bedroom Charlie and Donnie shared at 1728 Lamont Street. (Courtesy Donald Schwarz.)

The Park Road triangle park (see page 36) was a favorite hangout for teenagers in the late 1950s and early 1960s. Boys ran with gangs (tame by today's standards) named the Mount Pleasants, the Interns, the Hearts, and the Rebels, which were linked to different parts of the neighborhood. Here, from left to right, Donnie Schwarz, Artie Wong, Eddie Morris, and Al Batres, members of the Mount Pleasants, waited for something to happen. (Courtesy Arthur Wong.)

Bob Sciandra (right) worked with two classmates on the Bell Vocational High School newspaper in 1960 (see page 61). In the Bell program, students sampled a variety of vocational courses before choosing a specialty, such as printing. After that, they spent half of each day in the print shop and the other half in English, math, and other courses. (Courtesy Sciandra family.)

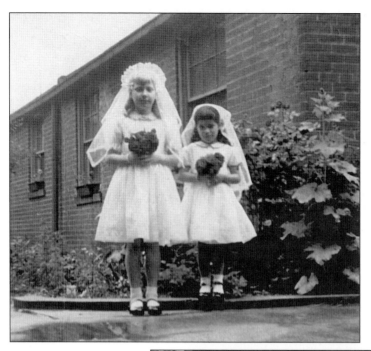

Anne Buffington (left) and Mary Santiago posed in their white May procession dresses and veils in the alley behind Harvard Street about 1959. This was the last year of Sacred Heart's tradition of schoolchildren marching around Cardinal Gibbons Park and into Sacred Heart Church (see pages 56–57), where one girl—a senior at the academy—placed a crown on the head of a statue of the Blessed Mother. (Courtesy Rosario family.)

From left to right, Robbie Browning posed with neighbors Joe, Bobby, and Mike Sciandra in front of the Monroe Street entrance to Gunton-Temple Memorial Presbyterian Church about 1951. Twelve years later, the church moved to Maryland and sold its building to the African American Canaan Baptist congregation. (Courtesy Sciandra family.)

In June 1963, Canaan Baptist Church became the first African American place of worship on Sixteenth Street when it moved from 5714 Georgia Avenue to the former Gunton-Temple Memorial Presbyterian Church. Here members waited to enter the church for the first time after marching in a procession from the old building. The church's original name, which honors an early benefactor, Mary Gunton-Temple, remains over the door. (Canaan Baptist Church.)

James Padgett Jr. (left), the artist who painted the mural behind the baptismal pool in Canaan Baptist Church, was the recipient of the congregation's first scholarship, in 1971. Founding pastor Dr. M. Cecil Mills (second from left) established the scholarship fund, which after his death was named for him. Eliza A. B. Jones (middle), Alice Mills, and David Jones helped mark the occasion at the church's front entrance. (Canaan Baptist Church.)

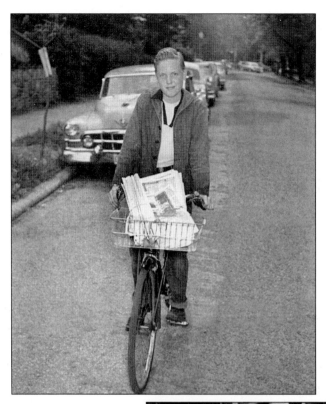

Many neighborhood boys who grew up in the 1940s and 1950s had paper routes. Fred Hays, of 1835 Newton Street, remembers delivering the *Washington Daily News* to Jimmy Dean at his 3303 Eighteenth Street rooms (see page 91) and to Bo Diddley at his 1724 Newton Street apartment (see page 92). He also delivered papers to 3423 Oakwood Terrace (see page 20), which had become a rooming house. (Courtesy Fred Hays III.)

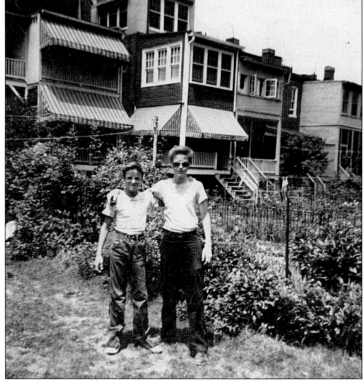

Donnie (left) and Charlie Schwarz posed in the backyard of their family's house at 3333 Eighteenth Street in 1959. The boys planted their own garden, growing carrots, cucumbers, tomatoes, and lettuce. Donnie and a friend got into trouble after stripping a neighbor's grapevine and leaving a trail of grapes. They made wine, bottled it, and buried the bottles in the yard to ferment indefinitely. (Courtesy Donald Schwarz.)

Rosario children and friends crowded into a wading pool in the Rosarios' backyard at 1614 Hobart Street in July 1957, as mothers Clara Santiago-Serano (right) and Carmen Rosario supervised. Vilma Rosario (third from left in the pool) recalls that they walked about a block to Bill's Timely Esso Service at 3054 Mount Pleasant Street to have the pool inflated. (Courtesy Rosario family.)

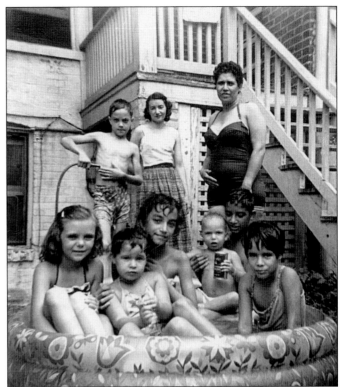

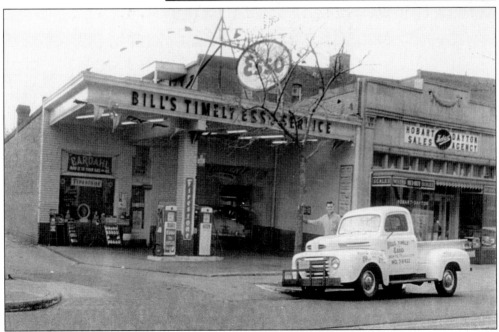

Bill Riddle posed in front of his gas station at 3054 Mount Pleasant Street about 1959. Neighborhood boys pumped gas here, and one of them, Bill Katopothis, later bought the building. In the mid-1980s, Salvadoran immigrant Wilson Amaya opened an auto mechanics shop here. (Courtesy Bill Katopothis.)

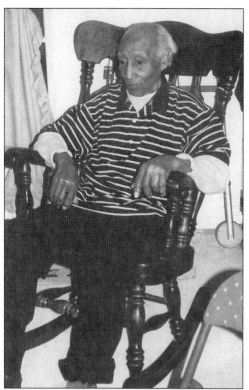

Harry Townsend began working in construction about 1920, for a company that built houses all over town. In 1956, he moved his family from Brookland in Northeast Washington to 1730 Kenyon Street, a house he quite possibly had helped construct in 1923. In his 90s, he was still doing odd jobs for neighbors. Townsend is seen here in 2004, just before he died at age 102. (Courtesy Louise Townsend Smith.)

Marshall and Jeff Logan were strolling around Mount Pleasant one day in 1964 when they found a tailor shop with an owner willing to sell. The couple, who had met in tailoring school, bought the business, seen here in the 1970s. In 1976, they opened an antique store across the street and eventually closed the other business. (Courtesy Jeff Logan.)

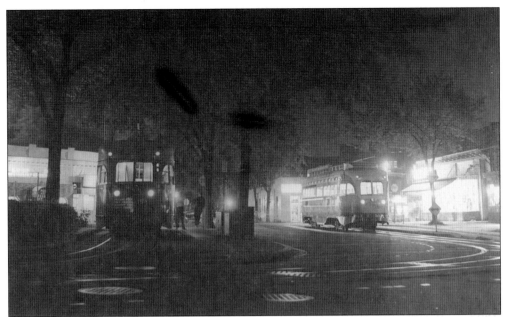

Five-year-old Richard Hardy remembers his family driving into Mount Pleasant for the first time one night in 1961 and seeing a lit-up streetcar, like the ones in this photograph, stopped on Lamont Street. He thought it was a carnival ride. The Loop Restaurant, 3203 Mount Pleasant Street, is visible at left, and David's Men's Store, 3182 Mount Pleasant, to the right. (Photograph by Paul Dolkos, courtesy Leroy O. King Jr.)

From top to bottom, Bobbette, Richard, and Steven Hardy were photographed on their front porch at 2024 Pierce Mill Road in 1967. The three had moved with their parents, Robert and Beulah Hardy, from West Virginia in 1961. Richard Hardy remembers a multi-racial block with many children for playmates. As for the adults, people were friendly and polite, but they knew their boundaries, he says. (Courtesy Richard Hardy.)

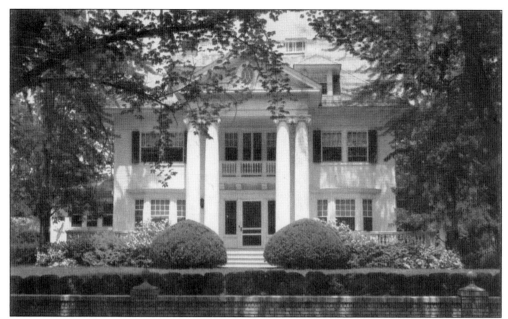

After Byron Adams died in the late 1930s, his house at 1801 Park Road (see page 32) became a home for the elderly known as Oak Retreat Sanitarium and later A Pleasant Place, as seen on this 1967 postcard. Neighbors organized to prevent a developer from razing the house in the late 1970s, but a compromise allowed him to convert it into condominiums and build an addition. (Collection of Wes Ponder.)

Audience members tried out the "sit-upons" at the Back Alley Theater for children, run by Naomi Eftis at 1929 Lamont Street in 1967. Neighbor Gloria Mitchell remembers that in the 1960s people organized a variety of activities for the neighborhood youngsters: Halloween parties, Easter egg hunts, games, and a talent show in the alley. (Washingtoniana Division, D.C. Public Library.)

Five

AN URBAN VILLAGE
A Distinctive Place in the World

The riots that followed the April 1968 assassination of the Reverend Dr. Martin Luther King Jr. devastated the Fourteenth Street corridor and engendered fear and mistrust among Washingtonians. Many white families left the city, and by 1970, Mount Pleasant was 70 percent African American.

The neighborhood's low housing prices after the riots attracted artists, political activists, and new immigrants, as well as young professionals looking for a mixed, close-in, urban community. Group houses formed in every block.

Some of the nearby Sixteenth Street churches have long been centers of political activism. All Souls Unitarian, an early and strong participant in the civil rights movement, in 1972 became the first home of Antioch Law School, whose mission was to train public-interest lawyers.

A tenant fight in Mount Pleasant's Kenesaw Apartment House led to landmark housing legislation. Renowned jazz trumpeter Webster Young (1932–2003) was a member of the first Kenesaw tenant co-op.

The first Latino grocery store, or *bodega*, in Mount Pleasant opened in 1962, quickly becoming a social center for the city's Spanish-speaking community and drawing other Latino businesses to Mount Pleasant Street. It also attracted Latino residents to the neighborhood.

After tensions between the D.C. police and some members of the Latino community erupted in violence on Mount Pleasant Street in May 1991, the city was forced to reexamine the way it interacted with its Spanish-speaking residents.

By 2000, blacks, whites, and Latinos were almost evenly represented in the neighborhood. More recently, however, political changes and massive redevelopment have made the city more attractive to people of means, mostly whites, who have been moving to convenient, older neighborhoods such as Mount Pleasant. Many group houses have reverted to single-family use, and tenants have been forced out by rent increases and condominium conversions. A more homogeneous neighborhood has been the result.

However, a strong Latino presence remains. Many of the small businesses on Mount Pleasant Street continue to be owned and operated by Latinos.

Through all the changes, Mount Pleasant continues to be a distinctive place—one that has won the hearts and remained in the memories of the many people who have passed through it.

In the riots that followed the April 4, 1968, assassination of the Reverend Dr. Martin Luther King Jr., the nearby Fourteenth Street corridor was largely destroyed. Some Mount Pleasant Street businesses were vandalized, too. Ruth Holly remembers looking out the second-story window of her Lamont Street house and seeing the fires. Here soldiers took a break in front of the boarded-up Safeway at 3178 Mount Pleasant Street. (Courtesy Mary Leckie.)

Soldiers patrolled Mount Pleasant Street in the wake of the April 1968 riots. This photograph also shows the Oasis, a popular rock 'n' roll club that operated in the basement of 3171 Mount Pleasant Street during the 1960s. (Courtesy Mary Leckie.)

David's Men's Shop, at 3182 Lamont Street (now Don Juan's Restaurant and Carryout, 1660 Lamont Street), was one of the businesses that was vandalized and looted during the April 1968 riots. Neighbors remember that the only thing that remained afterwards was a mannequin. (Courtesy Mary Leckie.)

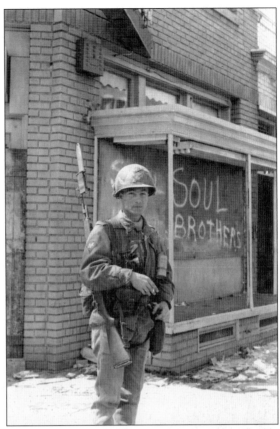

Following the April 1968 riots, a group of residents—members of Mount Pleasant Neighbors Association—organized a festival to bring the community together and bolster morale. The first few years, the event was held on the Bancroft playground. Neighborhood activist Rose Whiteside, seen here, helped organize the festival. Behind her are temporary classroom buildings meant to ease overcrowding at the school. (Photograph by Wolsey Semple.)

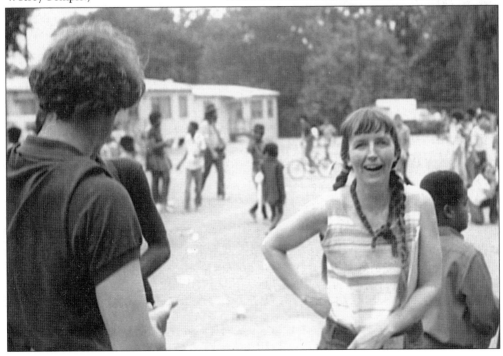

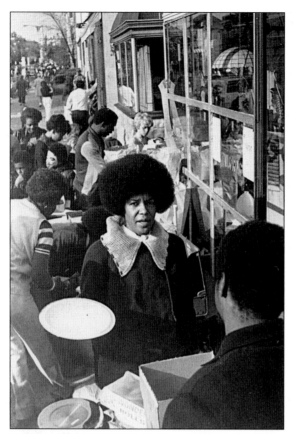

About 5,000 people attended the 1974 festival on Mount Pleasant Street and ate hot dogs, chicken, cakes, and pies provided by neighbors or purchased with donations from merchants. The event also featured dancing to the Latin American soul and rock group the Zapatas. Jeff Logan, seen here, tended to a food table in front of her tailor shop at 3125 Mount Pleasant Street. (Photograph by Wolsey Semple.)

Ken Vallis (top right), a member of Mount Pleasant Neighbors Association and a festival organizer, was photographed near Logan's tailor shop during the 1974 event. (Photograph by Wolsey Semple.)

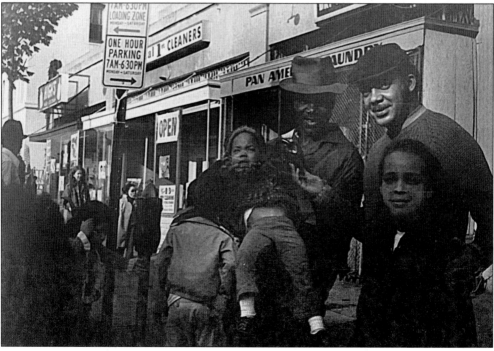

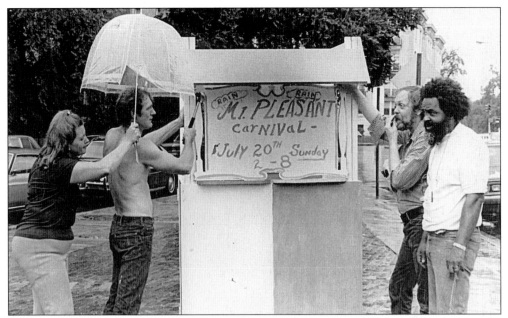

From left to right, Judy and Larry Fredette, along with Fred Hays and Marshall Logan, posted a rain date notice for the 1975 festival on Mount Pleasant Street near Park Road. Fred Hays first moved to Mount Pleasant in 1946, Larry Fredette in 1961, and Judy Fredette in 1968, after she married Larry. Logan opened a business on Mount Pleasant Street in 1964. All remain in the neighborhood. (Courtesy Jeff Logan.)

In the mid-1970s, Larry Fredette organized a boys' club on Kilbourne Place. Three boys showed up for the first meeting and 35 for the next one, Fredette remembers. Neighbors provided a garage and an old car, so the boys learned auto mechanics. Most of the young men who posed for this picture on Mount Pleasant Street, including Leon Williams (wearing the hat), participated in the club. (Photograph by Wolsey Semple.)

One of the first city-wide Latino leaders to emerge was Carlos Rosario, seen here with his wife, Carmen, at home on Hobart Street in 1960. Rosario had arrived on the U.S. mainland from Puerto Rico in 1950 to work for the government and in 1957 was transferred to Washington. He was instrumental in getting the D.C. Office of Latino Affairs established in 1976 and became its first director. (Courtesy Rosario family.)

Since his arrival in Washington, Rosario had been working to build a cohesive Latino community by organizing dances and other social events. The first Latino Festival in 1970 was a way for the community to make its presence known. Pre-festival events that year included a popularity contest sponsored by Rosario. Here he crowned Carmen Marrero as Señorita Primavera (Miss Spring). (Courtesy Carmen Marrero.)

The Latino Festival evolved with the community. During the 1980s, huge numbers of Central Americans arrived in Washington, particularly Salvadorans displaced by the civil war (1979–1991). To demonstrate the precarious legal status of many of the immigrants, the organizers of the 1987 festival chose an undocumented worker as the grand marshal of the parade marking the festival's start, as seen here. (Photograph by Rick Reinhard.)

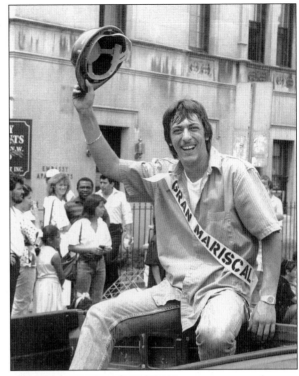

Carmen Marrero, holding her daughter, Jessica, marched on Mount Pleasant Street during the 1983 Latino Festival. Until the festival was moved downtown in 1989, the parade started in Mount Pleasant and concluded in Kalorama Park, and later Columbia Road. The festival returned to Mount Pleasant in October 2006. (Courtesy Carmen Marrero.)

All Souls Unitarian Church had a politically active congregation almost from the start. It was one of the few places in Washington where interracial groups could meet, and its pastor in the 1940s, the Reverend A. Powell Davies, helped lead the campaign to desegregate D.C. public schools. In 1974, the congregation invited Black Panther Angela Davis to speak in the sanctuary, as seen here. (Photograph by Nancy Shia.)

In 1965, Vilma Rosario, Carlos Rosario's daughter, began working with the United Planning Organization to help Barney House, a settlement house at 3118 Sixteenth Street, tailor its programs to its Spanish-speaking constituency. Pictured is a meeting Barney House hosted at All Souls Unitarian Church on social services for Latinos. (Courtesy Rosario family.)

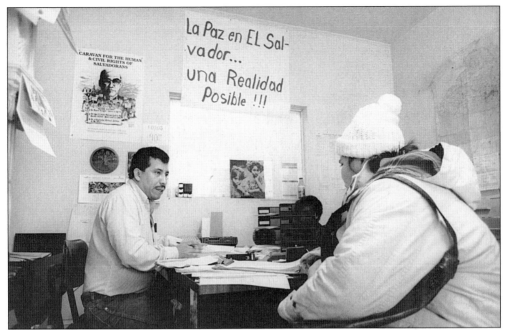

The Central American Refugee Center (CARECEN) opened at 3112 Mount Pleasant Street in 1981 to help Salvadorans and other Central Americans who were fleeing war, turmoil, and human rights violations in their countries. In this 1991 image, a counselor assisted a client under a poster that announced "Peace in El Salvador, a possible reality." CARECEN now has its own building at 1460 Columbia Road. (Photograph by Rick Reinhard.)

A Sacred Heart tradition since the late 1970s is the Good Friday Drama of the Passion, in Spanish, followed by prayers and songs in several languages. The evening culminates with a candlelight procession from the church along Park Road, down Mount Pleasant Street to Harvard Street, and back along Sixteenth Street to the church. Sacred Heart (see page 56) celebrates mass in Spanish, Vietnamese, Haitian-Creole, and English. (Photograph by Malini Dominey.)

109

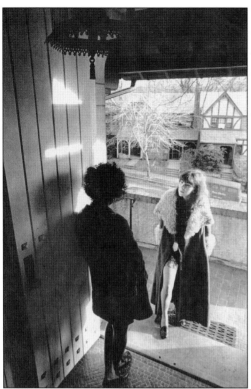

A student social worker counseled one of the residents of the House of Mercy in January 1972 (see page 40). During the late 1960s, just before it closed, the maternity home changed its program, allowing new mothers to stay until they were ready to leave. It also began offering "rap sessions," in addition to chapel services. (Washingtoniana Division, D.C. Public Library.)

In 1972, the House of Mercy's board converted the maternity home into the Rosemount Infant Day Care Center. It is now known as the Rosemount Center/El Centro Rosemount, offering a bilingual preschool program and family services. Teacher Catherine (Kitty) McKee posed with some of her charges in 2002. The facility sits slightly east of the old estate for which it was named (see page 15). (Courtesy McKee family.)

The exclusively white Presbyterian Home (see page 35) moved to upper Northwest in 1961 and was replaced by the Stoddard Baptist Home. In 1979, Stoddard decided to replace its building with a new one, but neighbors sought landmark status for the building. It stood empty while negotiations continued and in 1983 was seriously damaged by fire. Renovations started in the mid-1980s, as pictured. (Library of Congress.)

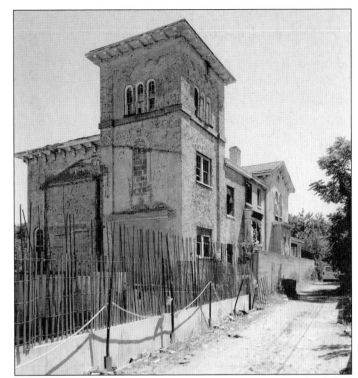

Founded in 1902 with funds from Marie Stoddard, a white Baptist philanthropist, Stoddard Baptist Home started as a retirement facility for Baptist ministers. After it was enlarged in 1986, it became a nursing home serving mainly African Americans. John Boger and Mary Butler were crowned king and queen in May 1991 as part of a celebration of Nursing Home Month. (Stoddard Baptist Home.)

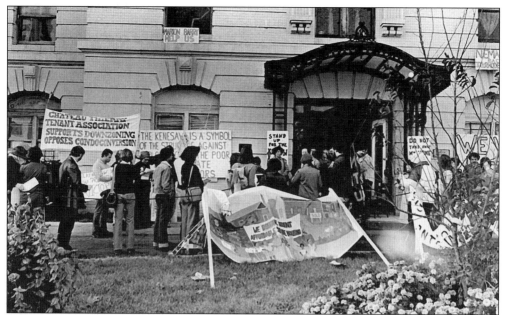

In the mid-1970s, the Antioch College of Law, the unhappy new owner of the dilapidated Kenesaw Apartment House (see page 44), decided to sell the building. Upon receiving eviction notices, the tenants organized to buy it and eventually succeeded with the help of neighborhood organizations. Here tenant groups from around the city geared up in front of the Kenesaw in 1977 to demonstrate against condo conversions. (Photograph by Nancy Shia.)

Newly ordained Fr. Sean O'Malley ran the Spanish Catholic Center, housed in the Kenesaw, and helped the tenants in their struggle to buy the building. In this 1977 photograph, Father Sean baptized the son of Silverio Coy (left), a housing activist who worked with the Kenesaw tenants. O'Malley went on to become the archbishop of the Boston Diocese in 2003. (Photograph by Nancy Shia.)

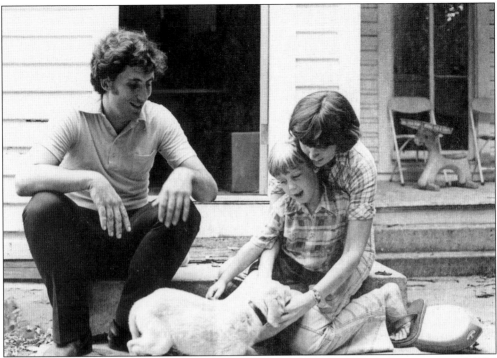

Spurred by the Kenesaw tenants' ordeal, D.C. Council member David Clarke cosponsored 1980 legislation that helps tenants citywide purchase their building when it is offered for sale, by giving them "the right of first refusal." Clarke (1944–1997) and his family moved to 3320 Seventeenth Street in 1977. In this 1978 photograph, Dave, Carole and Jeffrey Clarke enjoyed a summer day in their backyard. (Courtesy Carole Clarke.)

Mount Pleasant became a magnet for artists and political activists in the 1960s and 1970s. Group houses were a popular way to practice communal living and keep costs low. Here the Blue Skies extended family celebrated their fourth Thanksgiving at 1910 Park Road in 1975. Two of the original members of the group, Judy Byron (holding child with bottle) and Rick Reinhard (right), still live in the house. (Photograph by Rick Reinhard.)

In the early 1970s, La Casa Restaurant occupied 3166 Mount Pleasant Street, as seen here. The ecumenical Community of Christ bought it in 1974 and converted it to a place of worship and community center, also named La Casa. The building originally was constructed in 1902 as a private home for patent attorney Julian C. McDowell. Storefronts were added about 1928. (Photograph by Nancy Shia.)

A number of the newcomers to Mount Pleasant in the 1960s and 1970s were specifically seeking a racially mixed community. One of the neighborhood institutions during this period was the Children's Inn, run by Gail Whitley in her home at 3151 Nineteenth Street. Here some of "Mama Gail's" charges posed on the front wall. (Photograph by Ruth Holly.)

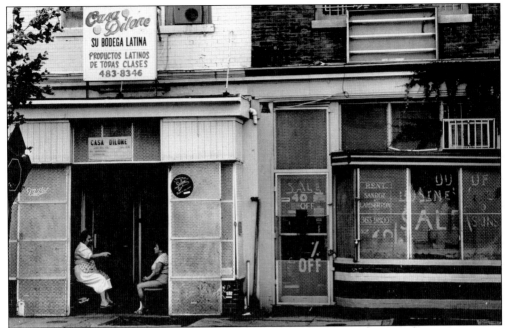

Francisca Marrero Diloné (left) chatted with Carmen Rivera at 3161 Mount Pleasant Street in 1991. When Diloné, an immigrant from Puerto Rico, and her husband, Félix Diloné, originally from the Dominican Republic, established Casa Diloné in 1962, it was the first Latino grocery in the neighborhood and one of only a handful in the city. It became a sort of social center. (Photograph by Nestor Hernandez.)

Rodolfo de León, pictured with son Julio (right), founded Leon's Shoe Repair at 3201 Mount Pleasant Street in 1979. The Guatemalan immigrant arrived in Washington in 1969 and found his way to Mount Pleasant, where other Central Americans were beginning to settle. A few years after de León's 1994 death, his son Randy took over the business. (Photograph by Nestor Hernandez.)

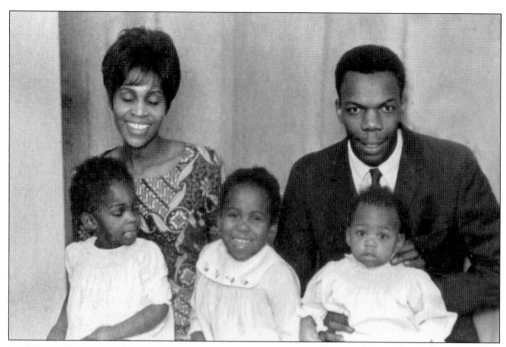

Sam and Dorothy Gilliam, with their daughters (from left to right) Melissa, Stephanie, and Leah, sat for a portrait at their 1752 Lamont Street home in 1967. The backdrop was a painting by Sam Gilliam, still one of Washington's major artists. Dorothy Gilliam continues to work in the field of journalism. (Courtesy Dorothy Gilliam.)

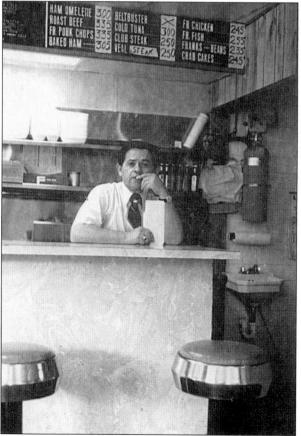

Insurance broker Chris Hondros bought the Little Giant diner, 3215 Mount Pleasant Street, in 1979 from his friend Spiro Kokalis, who then moved to Santorini, Greece, and built a hotel. Hondros, pictured here about 1982, kept Kokalis's manager, Arthur Simon, a "master on the grill" who could juggle 10 different orders. Simon and his brother bought the diner in 1985 and sold it in 2001. (Courtesy Dennis Hondros.)

With the advent of a new owner after the 1968 riots, the Fox Lounge, at 3253 Mount Pleasant Street (see page 36), became a gay bar after 6:00 p.m. The bar was on the ground floor, and the basement was a private party room. People still remember the windows with the shades drawn. Later in the 1970s, the Fox Lounge featured go-go dancers. (Collection of Wes Ponder.)

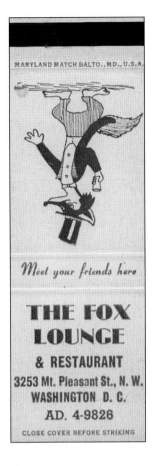

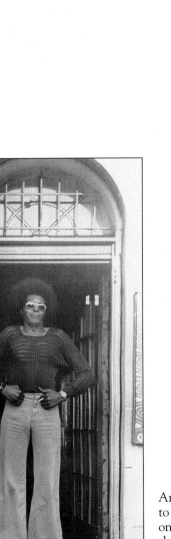

An unidentified man, dressed to the nines, surveyed the scene on Mount Pleasant Street from the doorway of Logan's Tailors, 3125 Mount Pleasant Street, in 1977 (see page 98). (Photograph by Nancy Shia.)

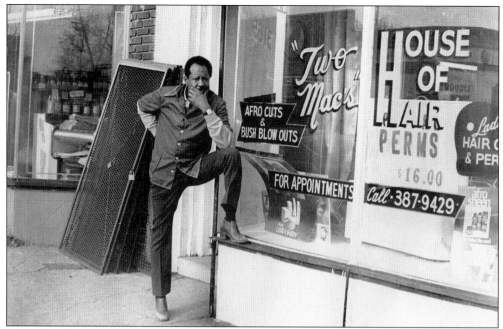

This hair salon operated at 3165 Mount Pleasant Street in the 1970s. Businesses at that address over the years included an upholsterer in 1938, a baker in 1940, a dry cleaner in 1943, a watch repair shop in 1954, and a florist and post office in 1956. Window grates became popular after the 1968 riots. (Photograph by Nancy Shia.)

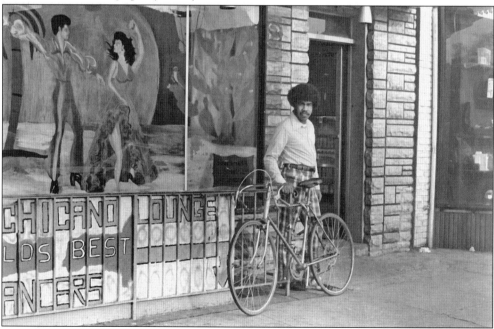

The Chicano Lounge operated in the basement of 3171 Mount Pleasant Street in the late 1970s. In the 1960s, this was the Oasis, a rock 'n' roll club remembered by Larry Fredette as "the swingingest place in Mount Pleasant." Link Wray and the Wraymen played there and so did the Fender Benders, a band associated with Wray. (Photograph by Nancy Shia.)

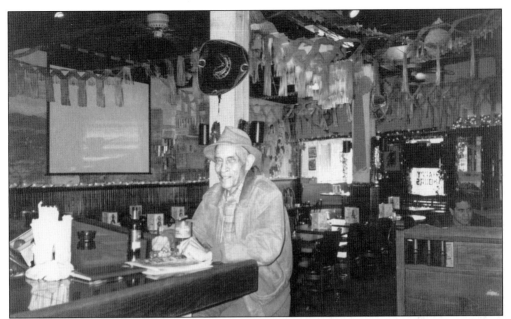

William Carr was photographed at Trolley's Restaurant, located at 3203 Mount Pleasant Street, about 1991. Back when many Washingtonians lived in rooming houses, Trolley's predecessor, the Loop Restaurant (see page 99), offered inexpensive meals—and a place to meet friends. Two regulars around 1960 were foot patrolman John Filippone and his then-wife, Maureen Reagan. The pair met in the neighborhood where he worked and she roomed. (Courtesy Latin American Youth Center.)

After immigrating from El Salvador in 1988, Nimia Haydee Vanegas attended Lincoln Junior High and Bell High School and worked at both the Latin American Youth Center and Trolley's. By 1990, she and her husband, Mario Alas, pictured with her, owned the restaurant. In 1997, they opened Haydee's at 3102 Mount Pleasant Street and then closed Trolley's. Larry Fredette painted the trolley mural. (Courtesy Latin American Youth Center.)

The Latin American Youth Center (LAYC) family, including Executive Director Lori Kaplan (lower left), gathered on the steps of the Wilson Center (see page 50), 3047 Fifteenth Street, in 1991. The organization was started in 1968 by a group of youths participating in a city-run leadership program. In 1974, it moved to a row house at 3045 Fifteenth Street, next door to the Wilson Center, a former church that had become the site of Latino cultural and political activism. The building's basement housed El Centro de Arte, started by South American activists who, among other activities, organized *peñas* that featured Latino artists. In 1998, LAYC moved to a newly renovated building on Columbia Road. Today it operates a network of youth centers, schools, and social enterprises around the city and has expanded into Maryland, following the many Latino and other immigrant families that have moved from D.C. The Wilson Center is now Capital City Public Charter School. (Photograph by Rick Reinhard.)

Lilo Gonzalez and members of his band, Los de la Mount Pleasant, performed in the Latin American Youth Center's nearly completed new building at 1419 Columbia Road in 1998. In one of his songs, Gonzalez, an immigrant from El Salvador, sings about the pain of leaving one's birthplace behind and the difficulty of adapting to a new home. One lyric declares, "No human being is illegal." (Courtesy Lilo Gonzalez.)

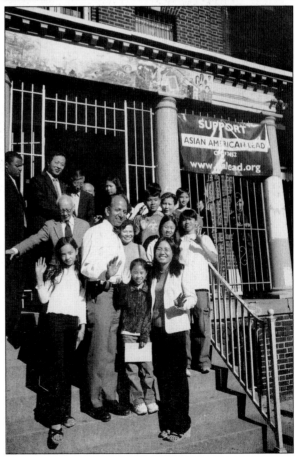

Mayor Anthony Williams (between two little girls) visited AALEAD (Asian American Leadership, Empowerment, and Development for Youth and Families) at 3045 Fifteenth Street in summer 2002. Sandy Dang (front) founded the group in 1998 and serves as its executive director. AALEAD operated out of the former Latin American Youth Center offices from 1998 until 2003, when it moved to its own building at nearby 1323 Girard Street. (Courtesy AALEAD.)

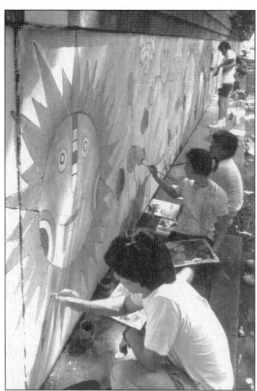

Young people from the Latin American Youth Center painted a mural along Klingle Road, including this section designed by Jorge Somarriba, in the summers of 1988–1990. The mural enlivens the wall below the Rosemount Center (see page 110) and marks one of the main gateways to Mount Pleasant at the edge of Rock Creek Park. (Photograph by Rick Reinhard.)

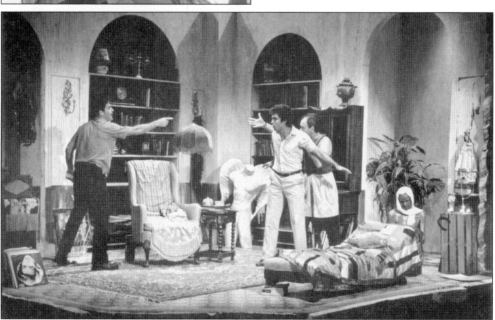

GALA Hispanic Theatre, founded in 1976 by Hugo and Rebecca Medrano as part of the Latino Festival, operated out of Sacred Heart School (see page 58) between 1985 and 2000. One of the group's 1996 productions was *Fresa y Chocolate* (*Strawberry and Chocolate*), pictured here. In 2005, GALA (Grupo de Artistas Latinoamericanos) moved into the restored Tivoli Theater at Fourteenth Street and Park Road (see page 67). (Photograph by Daniel Cima, courtesy GALA Theatre.)

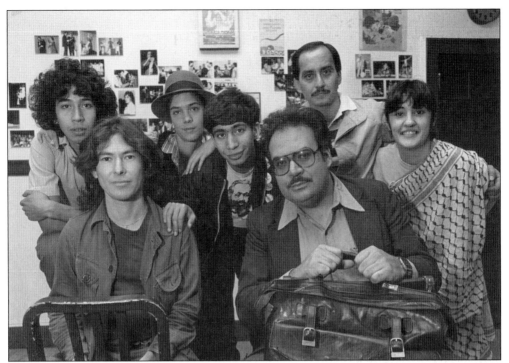

Teatro Nuestro started performing at El Centro de Arte (see page 120) and at neighborhood parks in the mid-1970s. The group, seen here, espoused the "collective creation" concept of the Latin American and Cuban New Theater movement. "Fifteenth and Irving was the epicenter of cultural/political activities," says Quique Avilés (center), who with his brother, Pedro Avilés (left), now runs El Barrio Street Theater. (Photograph by Rick Reinhard.)

Poet and actor Quique Avilés performed his one-man show, *Chaos Standing/ El Caos de Pie*, at GALA Hispanic Theatre, among other venues, in 1998. In the show, he played several quite different characters—including a young Salvadoran immigrant; an elderly African American widower; a young, white, female social worker; and a street drunk—thrown together in the same neighborhood. (Courtesy Latin American Youth Center.)

DC ARTs CEnteR and
GALA HiSPAniC theaTRe
present

CHAOS STANDING

el CAOS de PIE

(secOND par(E/el FuLL shOW)

another LOCURA written and
performed bY
QuiQuE AviLés
diRECted by B·STAnLey
Stile photogRaphy by
AllisOn sHelIY & RicK REinHard

3 SHOWS ONLY
FRIDAY, April 10, 7:30 p.m.
SATURDAY, April 11,
4 p.m. matinee and 7:30 p.m.
GALA HISPANIC THEATER
1625 PARK ROAD NW
$10 adults
students/seniors $5

FOR TICKETS
202/462-7833
funDEd by The Initiative to
Strengthen Inter-Group Assets

On May 5, 1991, frustrated young men converged on the neighborhood after a rookie police officer shot and wounded a Salvadoran man while responding to a disorderly conduct call in the 3200 block of Mount Pleasant Street. Here a trash can burned in front of a Church's Fried Chicken outlet at Mount Pleasant and Kenyon Streets. Later the entire building burned. (Photograph by Rick Reinhard.)

Police officers responding to reports of a riot May 5, 1991, assessed the situation under the awning of Kenny's Barbeque, 3066 Mount Pleasant Street. The disturbances continued for two more days and resulted in the arrests of 230 people and injuries to 50. A subsequent report by the U.S. Commission on Civil Rights found many problems in the relationship between the police and Latino residents. (Photograph by Nancy Shia.)

Fr. Mark Poletunow (left) and Fr. Donald Lippert (center), associate pastors at the Shrine of the Sacred Heart (see page 56), tried to calm tensions on Mount Pleasant Street May 6, 1991. Following the riot, Mayor Sharon Pratt Kelly established the Latino Civil Rights Task Force headed by Pedro Avilés (see page 123), and the police force worked to improve its interactions with Latino residents. (Photograph by Rick Reinhard.)

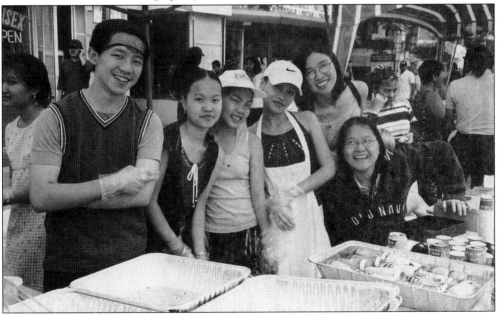

To help boost sagging spirits after the events of May 5–7, 1991, Pedro and Jean Lujan—former owners of Heller's Bakery—revived the Mount Pleasant Festival (see pages 80, 103–105). Young people from AALEAD (see page 121) sold out their supply of homemade (by their parents) spring rolls during one of the festivals, about 2002. They also sold fresh-squeezed lemonade. (Photograph by Joan Majeed.)

In April 2000, the Mount Pleasant Business Association organized the first Youth Arts Fair in the Children's Reading Room of the Mount Pleasant Branch Library (see page 53). One of the young participants posed with a cake donated by Heller's Bakery for the event's opening reception and awards night. (Photograph by Rick Reinhard.)

In the early 1990s, Mount Pleasant Main Street worked with the city to have Lamont Park renovated. The aging triangle park (formerly the Loop, see page 43) had fallen on hard times, becoming a center for drug dealing and other illegal activity. Hester Nelson, seen here, won a competition to redesign the space with a stage, benches, an arch, and decorative brickwork. (Photograph by Elinor Hart.)

A mariachi band performed on the new stage at the redesigned Lamont Park, during an art show. The park is used for a variety of activities, from skateboarding and ball playing to concerts, a farmers' market, and just hanging out. (Photograph by Elinor Hart.)

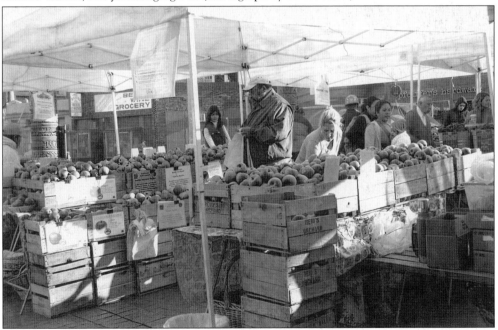

Every Saturday from May until Thanksgiving, Mount Pleasant residents flock to the Lamont Park farmers' market, started in 2003 by Nina Planck. To take part, vendors must raise, grow, catch, or bake everything they sell. They do not need to be certified organic but are encouraged to follow sustainable practices. (Photograph by Malini Dominey.)

ACROSS AMERICA, PEOPLE ARE DISCOVERING SOMETHING WONDERFUL. *THEIR HERITAGE.*

Arcadia Publishing is the leading local history publisher in the United States. With more than 3,000 titles in print and hundreds of new titles released every year, Arcadia has extensive specialized experience chronicling the history of communities and celebrating America's hidden stories, bringing to life the people, places, and events from the past. To discover the history of other communities across the nation, please visit:

www.arcadiapublishing.com

Customized search tools allow you to find regional history books about the town where you grew up, the cities where your friends and family live, the town where your parents met, or even that retirement spot you've been dreaming about.